TEACHING ART THE EASY WAY:
A COMPLETE ART CURRICULUM FOR GRADES K-3

By
Marcy Uphoff Effinger

Second Edition

RAINBOW ARTISTS PRESS
7014 248th Avenue
P.O. Box 254
Salem, WI 53168
(262) 843-3430 Phone/Fax
rainbowartist@msn.com

ISBN# 0-9633334-6-1

TEACHING ART THE EASY WAY: A COMPLETE ART CURRICULUM FOR GRADES K-3

Second Edition
Ninth Printing- Printed in the United States of America

This book is designed to provide information and step-by-step instructions in the use of various art materials. Reference is made to the use of various art materials. The author and the publisher are not responsible for accidents or injury relating to or in connection with these art materials. This book is intended for use as an art guide, however, caution should be used and manufacturer's instructions heeded while working on specific projects mentioned in this book. While every attempt is made to provide accurate information, the author and the publisher cannot be held responsible for any errors or omissions.

RAINBOW ARTISTS PRESS
7014 248th Avenue
P. O. Box 254
Salem, WI 53168
(262) 843-3430 Phone/Fax
rainbowartist@msn.com

ISBN# 0-9633334-6-1

This book is dedicated to:

My loving parents,

The most wonderful parents in the world,

Bonnie & Everett Uphoff,

and to:

My patient and wonderful husband,

Tom,

And to our two great children,

Matthew, who helped illustrate this book,

And

Megan, our other future artist.

I love you all very much!

I couldn't have done this book without you.

Love,

Marcy

INTRODUCTION

Dear Fellow Educators:

After searching for a good art curriculum for many years and unable to find a really good one, I decided to write my own book. The first book, for grades 4-8 was written after careful research and teaching children and adults for over 17 years. The suggested materials are inexpensive, easy to find materials.

After the first book, TEACHING ART THE EASY WAY: A COMPLETE ART CURRICULUM AND TEXTBOOK FOR GRADES 4-8, which was written in 1992, was met with such enthusiasm, I decided to write this book designed for grades Kindergarten - 3. Daily I receive phone calls and letters which request a K-3 book.

This is the perfect, easy to use curriculum for anyone. You don't have to be an artist to use this book. You don't have to do all the projects. This book has been designed to: PROVOKE CREATIVE THOUGHT THROUGH SIMPLE TECHNIQUES.

Although each lesson is geared for a certain grade level, each one can be adapted for another grade also. For example, if one wanted to teach a 3rd grade lesson to a kindergarten class, it would have to be simplified.

A few projects suggest using a hot glue gun. This should only be used by an adult, because serious burns may result if it is not used properly.

Some of the illustrations are children's own artwork. If so, the child's name and age will be stated. I would like to thank the children that helped me illustrate this book. Great job!

This book was designed to: HELP YOU, GUIDE YOU, INSPIRE YOU, AND ENCOURAGE YOU TO TEACH MANY LESSONS EASILY. So, get started, jump right in, and START: TEACHING ART THE EASY WAY.

Sincerely,

Marcy Uphoff Effinger

Marcy Uphoff Effinger

TABLE OF CONTENTS

***THE FOLLOWING PAGES MAY BE PHOTOCOPIED FOR STUDENT USE:
PAGES 18, 19, 54, 55, 56, 91 AND 93

TREES AND HOW TO DRAW THEM

1. The easiest way to draw trees is to draw the trunk first. The roots will only show on the top of the ground like this:

 NOT:

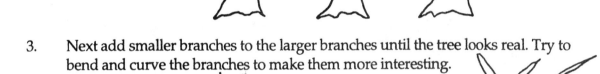

2. Next draw one, two, three, or four large branches attached to the trunk. Branches should not be straight. Branches will be thickest where they attach to the trunk and thinner at the ends.

3. Next add smaller branches to the larger branches until the tree looks real. Try to bend and curve the branches to make them more interesting.

4. To complete the picture, leaves, pine needles, or fruit may be added. Be sure to add a horizon line, so the tree isn't floating in the air.

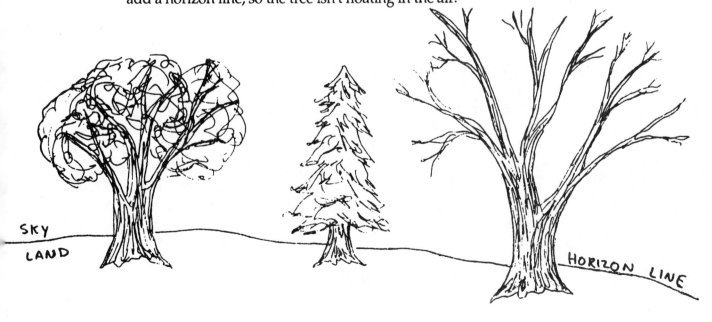

SKY
LAND

HORIZON LINE

TREES: SCENERY - KINDERGARTEN

SUPPLIES:

Pencil, paints, brushes, crayons, colored chalks or pastels, kleenex, and white or colored paper.

PROCEDURE:

1. Explain FOREGROUND and BACKGROUND. FOREGROUND is the part of a scene that is in the front of the picture, closest to the viewer. BACKGROUND is the part of a picture that is behind the foreground.

2. Explain HORIZON LINE. A HORIZON LINE is a line that separates the sky from the land. Above the line is sky, and below the line is land or water.

3. HILLS may be drawn overlapping like this:

4. Review the steps for drawing TREES on the previous page.

SUGGESTED ACTIVITIES:

1. Have students stand up and pretend to be trees, (with thick trunks and long branches). Then have the students draw or paint trees on paper. Leaves may be colored or painted after branches are drawn. Don't forget the horizon line.

2. Using colored chalks or pastels, (use dry or wet paper), make a scene with at least 1 tree. Use white paper for 1 picture and colored paper for another picture.

3. Draw trees with birdhouses, flowers, houses... with crayons on white or dark colored papers.

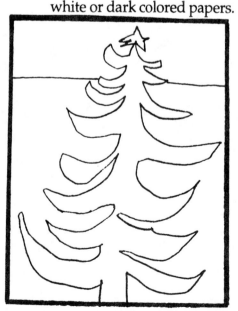
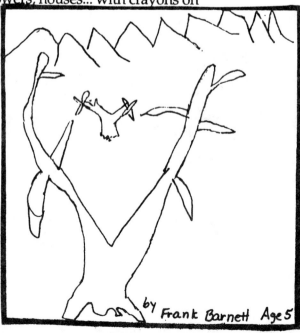

by Frank Barnett Age 5

TREES: PASTEL SCENERY - 1ST GRADE

SUPPLIES:

Pencil, 9 X 12 or 12 X 18 manilla or colored paper, kleenex, and colored pastels or chalks.

PROCEDURE:

1. Review the two previous pages on foreground, background, and trees.

2. Have students draw a scene with hills and trees using pastels or colored chalks. Color the sky first, and gently smear with a kleenex. Next color the hills, and background snow or grass.

3. After the background is colored with pastels, the trees may be added. DON'T SMEAR THE TREES. You may use greens, yellows, and blues for pine trees, and browns and blacks for the other types of trees.

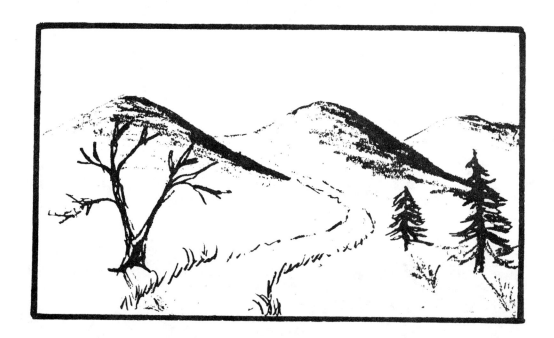

TREES: SNOW SCENE TREES - 2ND GRADE

SUPPLIES:

Pencil, scissors, glue, colored paper, white tempera paint, newspapers, and brushes.

PROCEDURE:

STUDENTS WILL BE MAKING A SCENE WITH AT LEAST ONE TREE AND OTHER OBJECTS GLUED ONTO A LARGE COLORED PAPER. SNOW WILL BE PAINTED ON THE TREES AND OTHER OBJECTS WITH WHITE TEMPERA PAINT.

1. Review the previous pages on tree drawing techniques.

2. Give each child a large piece of colored paper, for the background sky color, (light or dark blue, gray, or black).

3. Students will use other colored papers to draw and cut out trees, houses, fences, or any other details. Animals, cars, trucks, snowmen, or anything else may be drawn and cut out.

4. Arrange the cut out shapes into an interesting picture. When happy with it, glue all pieces on the larger paper.

5. Use tempera paint (white) to paint on the tops of objects in the pictures, like snow. For example: paint snow on the tops of tree branches, mailboxes, cars, fences. If you want snow on the ground, and a little in the background, go ahead and paint that also.

TREES: FANTASTIC TREEHOUSES - 3RD GRADE

SUPPLIES:

Pencil, ruler, large drawing paper, crayons, colored pencils, or markers.

PROCEDURE:

YOU WILL BE DRAWING A FANTASTIC TREEHOUSE!

1. Review previous pages on tree drawing techniques and 3D shapes and house techniques.

2. Have students draw a fantastic tree house, (before they draw the tree itself). The tree house can have one or more levels, furniture, windows, elevators. If possible, make parts of the treehouse look 3D.

3. Next draw the tree trunk and the branches around the treehouse. Some of them will be in the front of the treehouse, and some will be behind it.

4. When satisfied with the picture, it may be colored. Other details, such as animals or people may be included in the picture.

HOW TO DRAW 3 DIMENSIONAL SHAPES

SQUARE OR CUBE:

PYRAMID:

CONE:

CYLINDER:

A - FRAME HOUSE:

HOUSE:

BARN:

BOWL:

PLANTER:

VASE OR BOTTLE:

CASTLE:

DRAWING AND SHADING THREE DIMENSIONAL SHAPES
WITH A CAST SHADOW

1. Draw these 3D shapes. Be sure to use a compass and ruler.

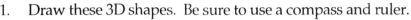

2. Draw an arrow next to each shape to show the direction of the light
 source. Draw the cast shadow directly opposite each arrow.

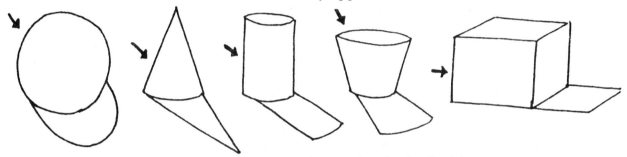

3. Using your pencil, charcoal, or graphite sticks, shade all of the cast
 shadows very dark. The areas closest to the arrows will be the
 lightest, and the shape will get gradually darker away from the
 arrow. Try to shade the shape so no single pencil lines are visible.

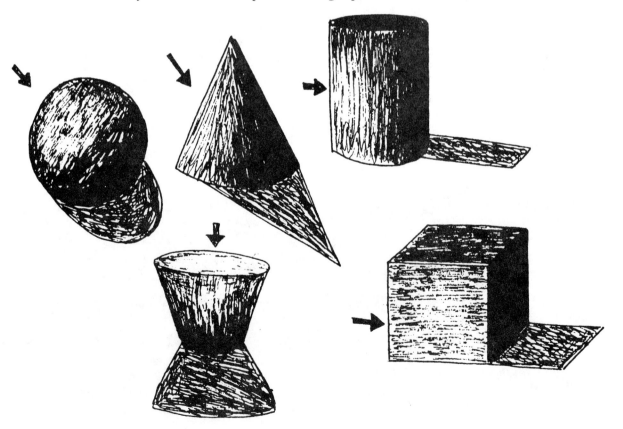

BASIC SHAPES - KINDERGARTEN

SUPPLIES:

Pencil, scissors, glue, colored paper, paints, ruler, brushes, newspapers, crayons, and white paper.

PROCEDURE:

BASIC SHAPES

1. Review these basic shapes with the children:

2. Have the children practice drawing and cutting out each shape. They can use rulers and trace round objects. Colors can also be reviewed by using different colors of paper.

3. These shapes may be glued onto another paper for an interesting design or picture. (See example below.)

USING THE BASIC SHAPES IN PICTURES

1. Draw or paint some simple drawings using the basic shapes: simple fruits, balls, flowers, cars, and Indian tepee, a house, trucks, or planets.

2. Use paints (watercolor, tempera, or fingerpaints) to make a design using one shape in various sizes. Shapes may be overlapped to make it more interesting.

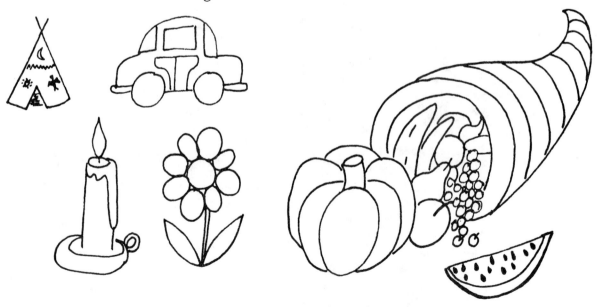

BASIC SHAPES - 1ST GRADE

PLATE OF FOOD FOR USING BASIC SHAPES

SUPPLIES:

Pencil, scissors, glue, colored and white paper, 1 paper plate per child, crayons or markers, and rulers.

PROCEDURE:

1. Review these basic shapes with the children:

2. Have children draw and cut out food to glue on the paper plates using the basic shapes. Details may be drawn on the paper with markers or crayons.

3. Use 12 X 18 piece of paper for the placemat, and decorate it with crayons or markers, or paper scraps.

4. Glue the paper plate of food onto the placemat. Be sure to add a fork, knife and spoon. See example below.

KITES TO HANG IN THE CLASSROOM

SUPPLIES:

Pencil, scissors, glue, colored and white paper, 1 paper plate per child, crayons or markers, and rulers.

PROCEDURE:

Pencil, scissors, glue, colored and white paper , crayons or markers, and rulers.

1. Review the above basic shapes with the children.

2. Have the students design kites, and decorate them with crayons or markers. Use the basic shapes, and repeat one or more of them. Be sure to overlap some of the shapes, and sizes of the shapes may vary.

3. Use yarn to make tails on the kites. They may be hung in the classroom with a piece of yarn.

BASIC SHAPES - 2ND GRADE

BUTTERFLY USING BASIC SHAPES

SUPPLIES:

Pencil, scissors, glue, black construction paper, assorted tissue papers, stencil paper, colored chalks, and yarn.

PROCEDURE:

1. Review these basic shapes with the children.

2. Give each child 2 pieces of black paper, (9 X 12 or 12 x 18). Fold 1 piece in half as shown, and cut it out.

3. Draw designs using basic shapes on 1 side of the butterfly. Be sure to keep it folded in half. Then cut out the designs as shown.

4. Trace the butterfly on the other black paper and cut it out too. Glue tissue paper scraps on 1 piece of black paper, then glue both black papers together. Hang up with a piece of yarn, or tape to a window.

CHALK STENCILS

1. Draw a basic shape on stencil paper or another stiff type of paper. Cut out the shape.

2. Using colored chalks on preferably dark paper, make an interesting design. See example below.

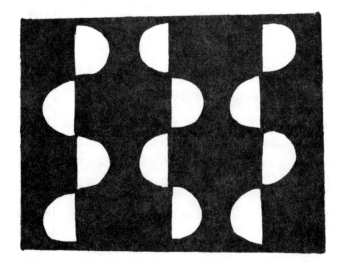

BASIC SHAPES: 3D SHAPES - 3RD GRADE

SUPPLIES:

Pencil, manilla paper, vine charcoal, kleenex, and a ruler, something round to trace, and chalk pastels.

PROCEDURE:

1. Review the basic 3D looking shapes with the class on the previous pages.

2. Have students draw the shapes with a pencil, and then shade them with vine charcoal. The charcoal may be gently smeared with a kleenex, and also erased if necessary. Be sure to use rulers, and trace round objects for the circles.

3. If time allows, let the students use another manilla paper, and draw some type of still life using the 3D looking shapes. For example: a bowl of fruit, a vase of flowers, a planter. Then let the students color the picture with colored chalk pastels. See example below:

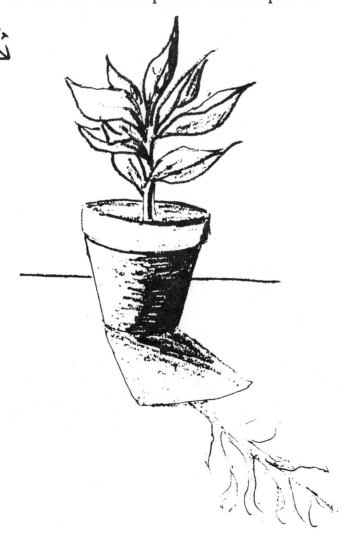

SIMPLE ANIMAL DRAWINGS

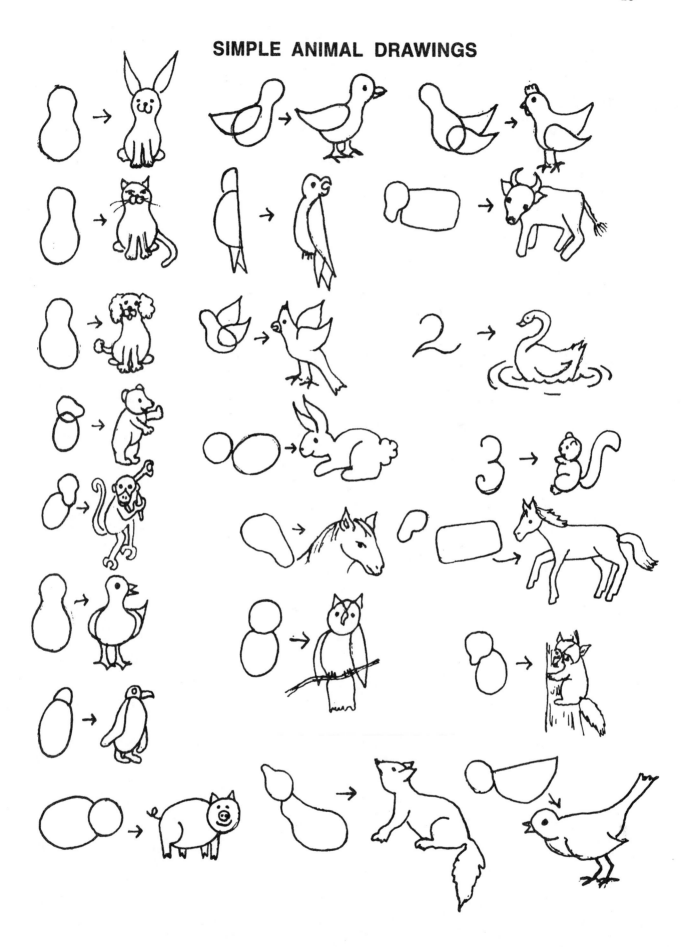

SIMPLE ANIMAL DRAWINGS

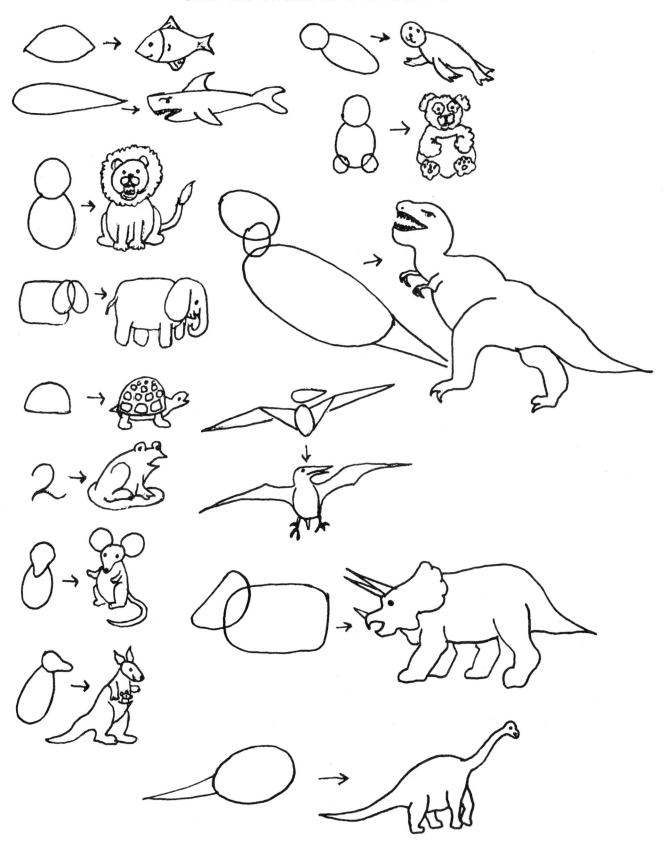

ANIMAL DRAWINGS - KINDERGARTEN

SUPPLIES:

Pencil, crayons, and large white or manilla paper.

PROCEDURE:

1. Animals can easily be drawn if the shapes are simplified. For example, many animals' bodies can be drawn using a simple pear shape. Others may be drawn using an oval or rectangle.

2. Have the students decide which animals they want to draw. It is much easier if they have a photograph to look at. Start drawing the animal lightly, using pear shapes, ovals, squares, or rectangles. Draw very lightly.

3. Add shapes for the rest of the animal. Then draw over the shapes to make the animal look more real. See examples below and on previous page.

4. Color the picture with crayons. Be sure to include a HORIZON LINE. (The line that separates the sky from the land.)

HORIZON LINE

by Matthew Effinger
Age 5½

ANIMAL DRAWINGS: CAGED ANIMALS - 1ST GRADE

SUPPLIES:

Pencil, ruler, scissors, glue, crayons, colored and white construction paper.

PROCEDURE:

1. Give each child a white piece of paper to draw the animals on, and a colored piece to make the cage.

2. On the colored paper, draw a cage, and cut it out. Be sure to use a ruler. See example below:

3. On the white paper, draw one or more animals. They can easily be drawn if the shapes are simplified into circles, ovals, rectangles, squares, or pear shapes. See examples on the previous pages.

4. When the animals are drawn, a background may be added. Color the picture.

5. Place the cage paper on top of the animal drawing. When happy with the position, glue it to the white paper. See example below:

Kangaroo family by Matthew Effinger

ANIMALS: ANIMAL BOOK - 2ND GRADE

SUPPLIES:

Pencil, crayons, markers, or colored pencils, and 2-4 pieces of 12 X 18 white or manilla paper per child. A stapler is helpful to staple books together.

PROCEDURE:

1. Animals can easily be drawn if the shapes are simplified. For example, many animals' bodies can be drawn using a pear shape, oval, rectangle, circle, or square. Have the students look at animal pictures.

2. Give each child 2-4 pieces of paper. Put then together, fold in half, and staple like a small book.

3. Draw animals on each page of the book. Be sure to include backgrounds on each page. You may wish to review trees to include in some of the pictures. You may also want to have students write a sentence or two about each animal on the top or bottom of each page. See examples of animal drawings on previous pages.

4. Pictures may be colored. If you want students to put a title on their books, you may want to review the BLOCK LETTER PAGE IN THIS BOOK.

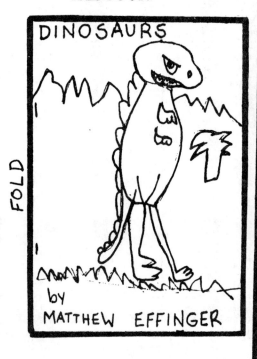

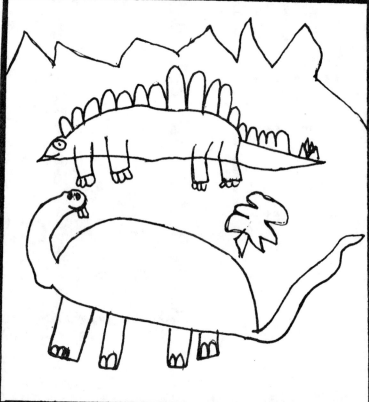

ANIMALS: THE FARMYARD - 3RD GRADE

SUPPLIES:

Pencil, colored pencils, markers, or crayons, rulers, and large white or manilla paper.

PROCEDURE:

1. Review the previous pages on ANIMAL DRAWINGS.

2. Review the previous pages on TREE DRAWINGS.

3. Review the previous pages on 3D BUILDINGS.

4. Have each student draw a farmyard scene, complete with a barn, animals of their choice, and a tree or two. They may add as much details as needed: a tractor, scarecrow, fence, plants.

5. Color when finished.

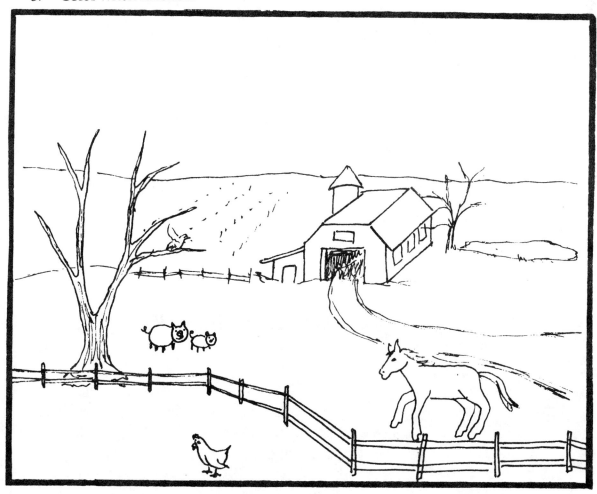

PORTRAITS

TIPS ON DRAWING PORTRAITS:

1. The head should be egg shaped, with the chin thinner.

2. The eyes are approximately in the center of the face.

3. Draw lines along the center of the head, and where the eyes, nose and mouth should be.

4. Add hair. See examples.

5. Attach a neck and shoulders as shown, not too thin or thick.

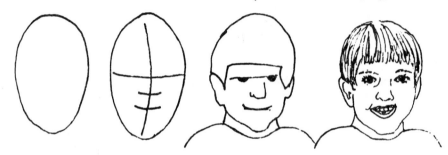

EYES, EYEBROWS, EYELASHES

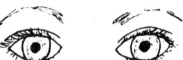

NOSES

MOUTH

EARS

HAIR SHOULD LOOK LIKE THIS. DRAW THE HAIR THE WAY IT GROWS. ATTACH A NECK AND SHOULDERS LIKE THIS:

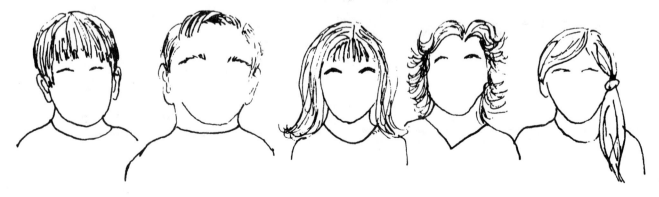

PORTRAITS: KINDERGARTEN

SELF PORTRAIT

SUPPLIES:

Pencil, crayons, chalk, paper, paints, and brushes.

PROCEDURE:

1. Review portrait drawing techniques on previous page.

2. Have students draw a self portrait on white or colored paper. Pictures may be colored or painted. Discuss how individual ears, hair, and faces are different. (See examples below.)

STUDENT PORTRAIT

PROCEDURE:

1. Review portrait techniques on previous page.

2. Pair up the students for drawing each other.

3. Have the students draw each other on white or manilla paper. Try to have the hairstyle match the individual being drawn. Color or paint when drawn.

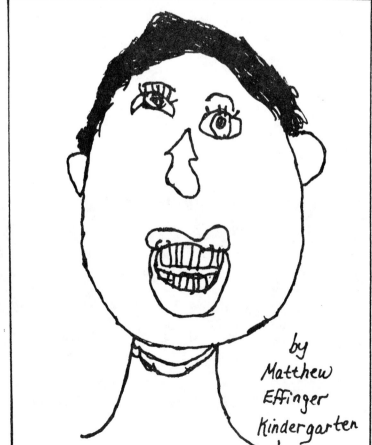

by Matthew Effinger Kindergarten

PORTRAITS - 1ST GRADE

SUPPLIES:

Pencil, crayons or markers, paints and brushes, and 12 X 18 white or manilla paper.

PROCEDURE:

1. Review portrait drawing techniques on the previous pages.

2. Discuss how people's faces look different to show their feelings: happy, sad, scared, sleepy, or mad.

3. Have each student draw a picture with two or more faces in the picture, and show different emotions in each face: happy, sad, scared, sleepy or mad.

4. Color or paint the pictures. See examples below.

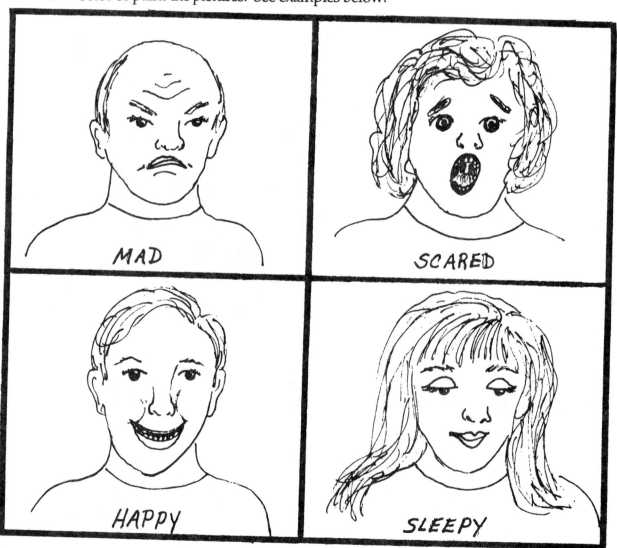

PORTRAITS: STUFFED CLOWN FACES - 2ND GRADE

SUPPLIES:

Pencil, scissors, tempera paints, brushes, newspapers, and staplers. Yarn, fabric scraps, glue, sequins, or pipecleaners may be desired to decorate the clown.

PROCEDURE:

BEFORE YOU BEGIN THIS PROJECT, LOOK AT VARIOUS PICTURES OF CLOWNS, AND TALK ABOUT HOW EACH ONE IS UNIQUE WITH SPECIAL FEATURES.

1. Review the techniques used in drawing portraits on the previous pages.

2. Decide what type of clown to make, and draw it on a large piece of white, colored, or kraft paper, (at least 12 X 18). The hair may be drawn, or later glued or stapled to the clown's face. CUT THIS OUT AND TRACE THE OUTLINE ON ANOTHER PAPER, (for the back of the clown's head).

3. Paint the face of the clown as desired. Let dry. Paint the other piece for the back of the clown's head. This can be painted as another face or the back of the head. Let dry.

4. Staple the two heads together, but leave an opening in the top about 4" wide, and stuff the head with small pieces of newspapers. Staple shut when full.

5. Add any extra details to clown (yarn, sequins...) Attach a piece of yarn to top of head, and hang it up.

PORTRAITS: YARN AND FABRIC - 3RD GRADE

SUPPLIES:

Pencil, scissors, glue, yarn and fabric scraps, 2 matching buttons per child, markers or crayons to draw the portraits, and white or manilla paper or tagboard to draw the portraits on. Use at least a piece 9 X 12 or larger for each child.

PROCEDURE:

REVIEW THE PREVIOUS PAGES ON PORTRAITS PLEASE.

1. Review the techniques to draw portraits.

2. Decide what type of portrait to make, and draw the outline of the face, the eyes, nose and mouth with a pencil.

3. When satisfied with the drawing, use a marker to go over the lines.

4. Yarn may be glued on for hair, eyebrows, eyelashes, beards, and mustaches. Buttons may be glued on for eyes.

5. To finish the portrait, fabric scraps or a ruffle may be glued on for the neckline. Paper may also be used.

PROFILES

(An Eye Close-up)

1. Lightly sketch a circle for the general shape of the head.

2. Lightly sketch in lines for the eyes, nose and mouth.

3. Add the hair and ears. The top of the ears should be relatively even with the eyes, and the bottom should be relatively even with the bottom of the nose.

4. Draw the eyes, eyelashes, eyebrows, nose, both lips and the neck.

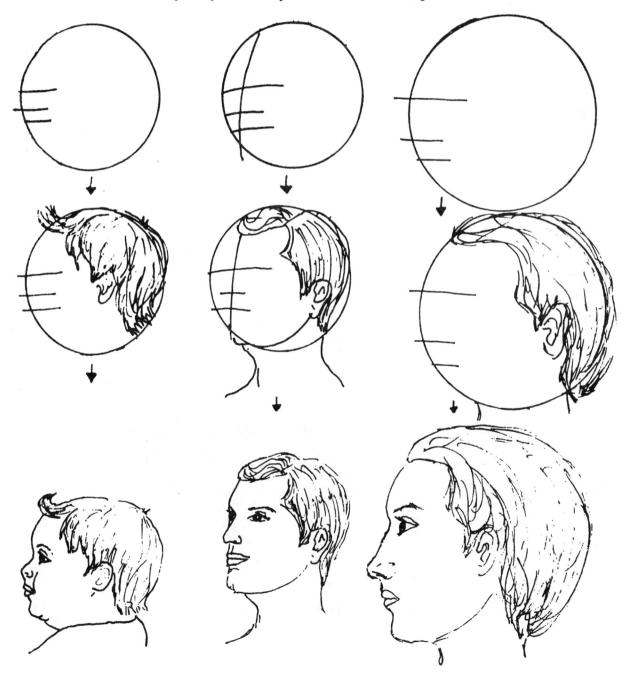

PROFILES: PROFILE SILHOUETTES - KINDERGARTEN

SUPPLIES:

Pencil, scissors, glue, white and dark paper, tape, and a bright light. A piece of chalk is also useful.

PROCEDURE:

1. Review the profile techniques on the previous page.

2. Give each child a white and a dark (black, brown, dark blue or dark purple) piece of paper, 9 x 12 or 12 X 18 is alright.

3. Seat a child in front of the chalkboard with one of the papers taped to the chalkboard next to him. (It should be even with his head.)

4. Put a light on the opposite side of the child, and trace the projected silhouette on the paper. If using dark paper, chalk shows up on it for the drawing. (See example below.) Use a pencil if using white paper.

5. Have students cut out the silhouette in 1 piece, and glue it on the other paper. (See example below.)

6. While students are waiting for their silhouette to be drawn, have them draw silhouettes of each other on white paper.

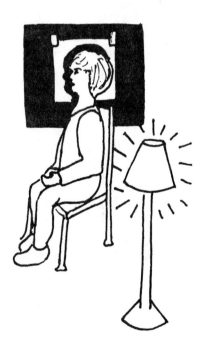
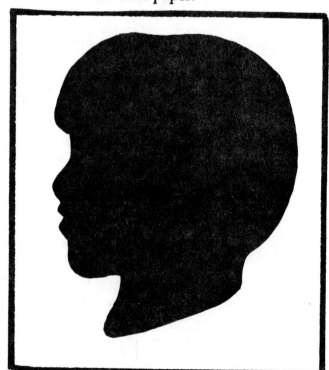

PROFILES: PAPER PLATE PROFILES - 1ST GRADE

SUPPLIES:

Pencil, scissors, crayons or markers, glue, colored papers, and yarn. Each child needs 1 paper plate.

PROCEDURE:

1. Review the profile techniques on the previous pages.

2. Give each child 1 paper plate. Draw a profile of a person as shown below.

3. Color eyes, mouth, ears, and any other details on the paper plate. Yarn or colored paper may be glued on for hair. See the finished example below:

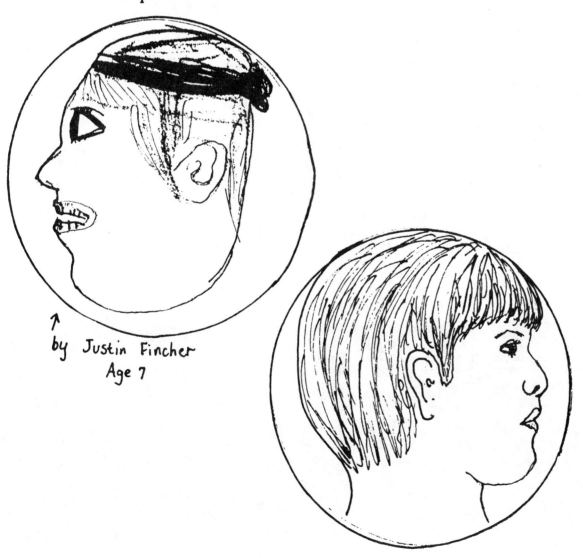

by Justin Fincher
Age 7

PROFILES - 2ND GRADE

SUPPLIES:

Pencil, crayons, paints and brushes, newspapers, and paper.

PROCEDURE:

1. Review the profile techniques on the previous pages.

2. Give each child a piece of white or manilla paper, (9 X 12 or 12 X 18).

3. Have students draw a profile of a person. It can be themself, a friend, a movie star, teacher, or an imaginary person. Make the profile as realistic as possible.

4. Profiles may be painted or colored. See example below:

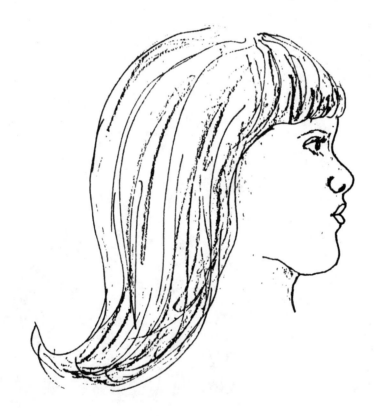

PROFILES: 2 PEOPLE FACING EACH OTHER - 3RD GRADE

SUPPLIES:

Pencil, scissors, glue, white and colored paper, crayons, paints and brushes.

PROCEDURE:

1. Review the profile techniques on the previous pages.

2. Give each child a white 12 X 18 piece of paper. Have the students fold the paper in half, and open it back up.

3. Draw a profile of a person facing the fold of the paper. Draw another person's profile on the other side of the paper, so the two faces are facing each other.

4. Color, paint, or use construction paper on the two profiles. See examples below:

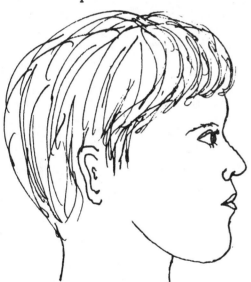 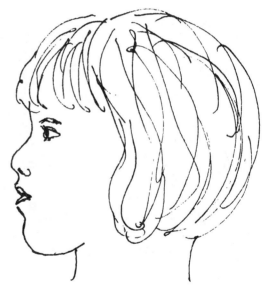

FIGURE DRAWING

TIPS ON FIGURE DRAWING:

1. Use geometric shapes or pieces of clothing to begin.

2. People have bones in their bodies. Don't draw rubber arms and legs.

3. A person's waist divides the body in half.

4. Children's heads are proportionally larger than adult heads.

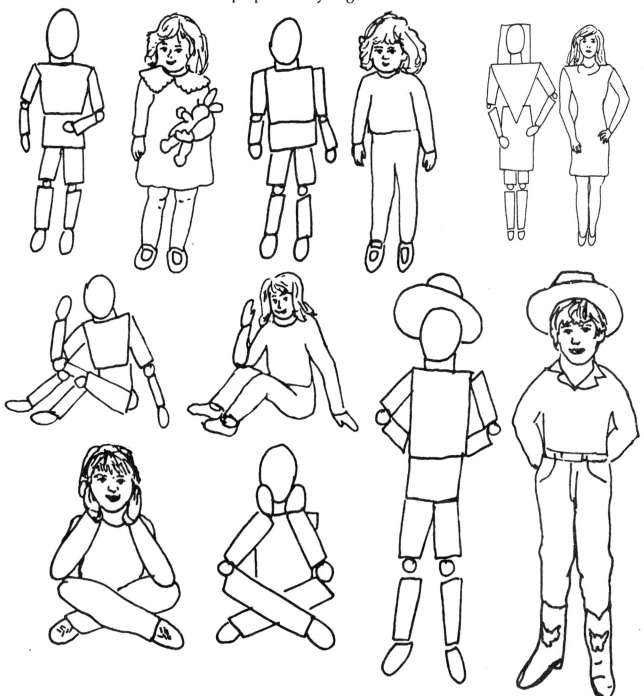

FIGURE DRAWING - KINDERGARTEN

SUPPLIES:

Pencil, crayons or markers, and a large piece of kraft paper for each child. Scissors are optional.

PROCEDURE:

1. Review techniques for figure drawing on the previous page. Review the portrait page also.

2. Trace around each child's body with a pencil on a large sheet of kraft paper. Arms may be bent or straight, and legs may be straight or bent to show action.

3. Have each child decorate, draw, and color their figure. Draw the face and clothes on the paper first. Children can use their imaginations, making themselves sport stars, movie stars...

4. Backgrounds may be colored, or the figures may be cut out and taped to the classroom walls.

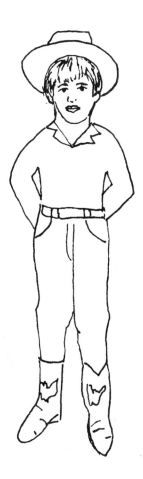

FIGURE DRAWING - 1ST GRADE

SUPPLIES:

Pencil, scissors, glue, crayons, white and colored paper.

PROCEDURE:

1. Review techniques for figure drawing on the previous page. Students will draw their whole family on 12 X 18 paper.

2. Using small paper scraps, draw and cut out clothing for family members.

3. Arrange the clothing on the paper for each person. When happy with the arrangements, glue them on a large piece of paper.

4. Draw the family member's heads, arms, legs, feet, and facial features. You may wish to review the portrait pages for facial features.

5. Students may color the rest of the picture with crayons.

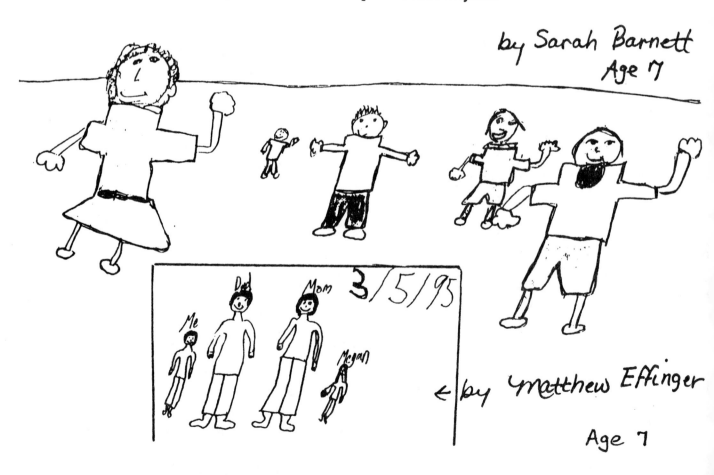

by Sarah Barnett Age 7

by matthew Effinger Age 7

FIGURE DRAWING: THE TEACHER - 2ND GRADE

SUPPLIES:

Pencil, 12 X 18 white paper, crayons or markers, paints and brushes, chalk, and the chalkboard.

PROCEDURE:

1. Review previous pages on figure drawing and portraits.

2. Let students practice drawing a person on the blackboard.

3. Give each child a large piece of paper, and have them draw the teacher. Begin by drawing the clothing, as shown below.

4. Next, draw the head, complete with features, hair, and a neck. Add arms, legs, hands, and feet.

5. Pictures may be colored or painted. See example below:

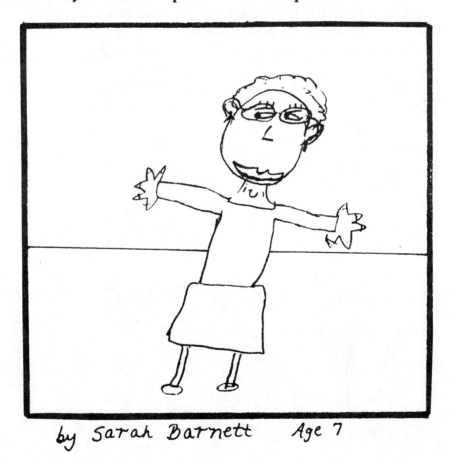

by Sarah Barnett Age 7

FIGURE DRAWING: CLASSMATES - 3RD GRADE

SUPPLIES:

Pencil, 12 x 18 white or manilla paper, and crayons, colored pencils, or markers.

PROCEDURE:

1. Review previous pages on figure drawing, portraits, and profiles.

2. Give each child a large piece of paper, and have one student stand on the teacher's desk, (to be a model). Modeling for 10 - 13 minutes is plenty of time for the students to draw the figure. Arms may be straight or bent. Legs may be straight or bent. Faces may be in full view, like a portrait, or sideways, like a profile. Have students concentrate ON THE BODY SHAPE, NOT SPECIFICALLY THE FACE.

3. Have another student model, and the students can draw her on the same paper. Try to vary the poses a little. If time allows, more students may model. (This works well over two or more art periods. The children love to draw each other and model.)

4. Pictures may be colored with any materials. See examples below for suggestions:

DRAWING - IMAGINATIVE

PLAN A TRIP IN TIME

Plan a trip "back in history" or go on an adventure with a famous author of an exciting book, such as: Peter Pan, Alice in Wonderland, Gulliver's Travels, or Huckleberry Finn.

SUGGESTED ACTIVITIES:

1. Draw or paint a picture of the trip.

2. Make a map of the trip. Use white paper or an old brown paper bag.

3. Design a postcard from the trip. Cut paper to the exact size of a postcard. Design a stamp for the postcard also.

4. Write a "Captain's Log" or Journal about your trip.

5. Make travel posters for your trip. Use block letters, drawn or cut out and glued on.

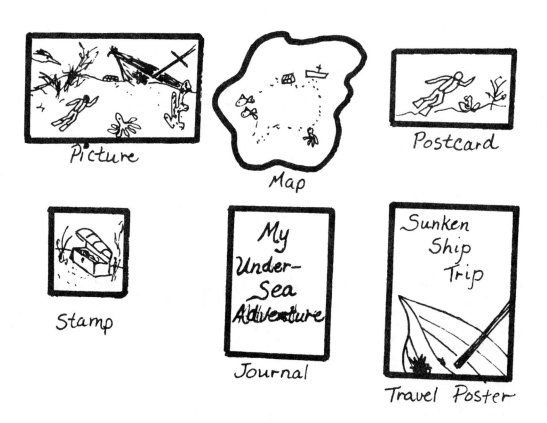

Picture Map Postcard

Stamp Journal Travel Poster

DRAWING - IMAGINATIVE

INVENT A NEW HOLIDAY

Review holidays, their origins and symbols in the United States and in other countries.

SUGGESTED ACTIVITIES:

1. Invent a new holiday and its symbols. Draw or paint a poster of the new day. (Dinosaur day: bones, Purple day: grapes...).

2. Use printmaking techniques to make notecards, stationary, or wrapping paper to celebrate the new day. Review printing unit.

3. Make classroom mobiles to celebrate the new holiday.

4. Make puppets to commemorate the new holiday. Write and perform a play about the new holdiay. Review the puppet unit.

5. Design masks or costumes to celebrate the "New Holiday". Review the mask unit.

Poster

Owl Notecards

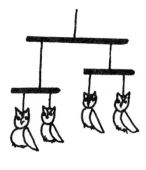

Mobile

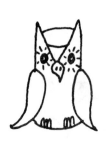

Toilet paper
roll- puppet

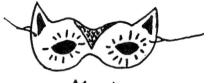

Mask

DRAWING - IMAGINATIVE

IMAGINE THE PERFECT ADVENTURE

Include yourself in a safari, deep sea diving, mountain climbing, as an astronaut in a spaceship, as a geologist...

SUGGESTED ACTIVITIES:

1. Draw or paint a picture of the adventure.

2. Make a map of the adventure. You could use white paper or make the map look very old by crumpling up a brown paper bag, smoothing it out, and cutting out the outside in an irregular shape.

3. Design a postcard from the adventure. You can use paper or tagboard cut the exact size as a standard postcard. Design a stamp for the postcard too.

4. Write a "Captain's Log" or Journal about your adventure.

5. Make travel posters for the adventure. Use block letters. The poster may be drawn, painted or colored. Letters can be drawn and colored or cut out of paper and glued on.

Picture

Map

Postcard

Stamp

Journal

Travel Poster

DRAWING - IMAGINATIVE

DESIGN A NEW INVENTION THAT COULD CHANGE THE WORLD

Read about famous inventors such as: Leonardo Da Vinci, Ben Franklin, Thomas Edison, Alexander Graham Bell...

SUGGESTED ACTIVITIES:

1. Draw or paint a picture of your new invention. Include what the invention does, and why it's needed.

2. Design a poster or a magazine ad for your new invention. The ad should be eye catching and use block letters.

3. Make a new invention sculpture using found objects, such as: egg carton, wood scraps, cardboard, cardboard tubes, yarn, straws, nails, plastic containers, wheels, toothpicks, assorted papers, paints. A glue gun (to be used only be an adult), works great when gluing these objects together. Inventions can move or be stationary.

4. Make a new toy that moves without batteries.

5. Design a new car that works without gas.

My New Invention

Magazine Ad

Invention Sculpture

New Toy - Noise Maker

New Car - Runs on Water Power

DRAWING - IMAGINATIVE

DESIGN A NEW, BETTER FUTURE WORLD

Read about Frank Lloyd Wright and other famous architects. Look at architectural drawings and blueprints.

1. Draw or paint a new, better world of the future.

2. Design the school of the future. Draw or paint the new and draw blueprints or floorplans too.

3. Design a house of the future. Draw or paint the new house, and draw blueprints or floorplans too.

4. Design the perfect kid's bedroom of the future. Draw or paint the new bedroom, and draw blueprints or floorplans too.

5. Design new clothing of the future. Color or paint them.

6. Make a 3D sculpture of the new world of the future. Use any scrap materials available, clay or paper mache'.

DESIGN

ELEMENTS OF DESIGN:

1. **LINE:** Lines may be thin, thick, in rows, or criss crossed, curved, the same thicknesses throughout, or varous thicknesses.

2. **SHAPE:** Geometric or free from shapes.

3. **COLOR:** Primary, secondary, tertiary, monochromatic, complementary...

4. **TEXTURE:** Smooth, rough furry, fuzzy, slippery...

5. **VALUE:** Bright, dull, light, medium, dark...

6. **SPACE:** Positive/negative, composition, perspective, spaces between...

PRINCIPLES OF DESIGN:

1. **UNITY:** this gives the design a quality of oneness, to make the design look "whole". But too much unity or similarity is monotomous. Too much variety is "confusing".

2. **BALANCE:** give a sense of stability to a design.

 1. <u>SYMMETRICAL OR FORMAL:</u> Equal distribution of identical, mirror image, elements of design, (such as a face, butterfly...).

 2. <u>ASYMMETRICAL OR INFORMAL:</u> This is the balance of unequal parts of a design. Both sides are not the same.

 3. <u>RADIAL:</u> This is a radiation of a design from a central point, such as a snowflake, wheel, star...

3. **VARIETY:** This is differences in size, line, shape, color, texture, value, or space in design. Too much variety is confusing, and too little variety is boring.

4. **RHYTHM:** This gives a design the quality of movement which is created through repetition of the elements of design.

5. **EMPHASIS:** This creates a center of interest in a design. It also focuses on the most important part of the design. This is done by changes in: texture, color, size, new materials, contracting shapes...

6. **OPPOSITION:** this gives the design exciting contrasts: smooth/rough, light/dark, horizontal/vertical...

7. **PROPORTION:** This is the relationship of parts to each other: width, heigth, depth, space...

DESIGN - KINDERGARTEN

DESIGN PROJECTS USING ONLY DOTS AS THE ELEMENT SHAPE.

SUPPLIES:

Pencil, paper, crayons, paints and brushes, or markers.

PROCEDURE:

REVIEW THE ELEMENTS OF DESIGN AND THE PRINCIPLES OF DESIGN ON THE PREVIOUS PAGE.

1. Draw and color a SYMMETRICAL & ASYMMETRICAL DESIGN using dots.

2. Draw and color or paint a design using SYMMETRY & ASYMMETRY using a VARIETY OF DOTS WHICH ARE DIFFERENT SIZES.

3. Draw or paint a design using RHYTHM as the main design focus. Use only dots in a variety of sizes.

4. Draw or paint a design which uses MOVEMENT as the main design focus. Use only dots in various sizes.

5. Draw or paint a design using various size dots, which use a combination of simple designs to make a more complicated one. Be sure to make sure the design is not too confusing or boring. This is called UNITY.

DESIGN - 1ST GRADE

DESIGN PROJECTS USING ONLY LINE AS THE ELEMENT SHAPE

SUPPLIES:

Pencil, paper, crayons or markers, paints and brushes, rulers, scissors and compasses.

PROCEDURE:

REVIEW THE ELEMENTS OF DESIGN AND THE PRINCIPLES OF DESIGN ON THE PREVIOUS PAGES.

1. Draw or paint a SYMMETRICAL & ASYMMETRICAL DESIGN using only lines.

2. Draw or paint a design using SYMMETRY & ASYMMETRY using a VARIETY OF DIFFERENT SIZE LINES.

3. Draw or paint a design using RHYTHM as the main design focus. Use only lines of different sizes and shapes.

4. Draw or paint a design which uses MOVEMENT as the main design focus. Use only lines of various sizes.

5. Draw or paint a design using a combination of simple designs to make a more complicated one. Be sure to make the design have UNITY, and not be too confusing or boring.

DESIGN: 2ND GRADE

DESIGN PROJECTS USING SHAPES

SUPPLIES: Pencil, paper, crayons, or markers, paints and brushes, rulers, scissors, and compasses.

PROCEDURE:

REVIEW THE ELEMENTS OF DESIGN AND THE PRINCIPLES OF DESIGN ON THE PREVIOUS PAGES.

1. Draw or paint a SYMMETRICAL & ASYMMETRICAL DESIGN using 1 shape. Cut out a pattern and trace it on the paper.

2. Draw or paint a design using SYMMETRY & ASYMMETRY which uses a VARIETY OF SIZES OF 1 SHAPE.

3. Draw or paint a design using RHYTHM as the main design focus. Use only 1 shape, but a variety of sizes of that shape.

4. Draw or paint a design which uses MOVEMENT as the main design focus. Use only 1 shape of various sizes.

5. Draw or paint a design using a combination of simpler designs to make a more complicated one. This is UNITY. Don't make the design too confusing or boring.

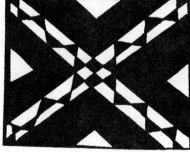

DESIGN: 3RD GRADE

DESIGN USING NATURAL AND MAN MADE OBJECTS

SUPPLIES: Pencil, paper, crayons or markers, paints and brushes, rulers, scissors, and compasses.

PROCEDURE:

REVIEW THE ELEMENTS OF DESIGN AND THE PRINCIPLES OF DESIGN ON THE PREVIOUS PAGES.

1. Draw or paint a SYMMETRICAL & ASYMMETRICAL DESIGN USING A SHAPE FROM NATURE (leaf, butterfly, flower, mushroom...). Use a variety of sizes of the shape. Patterns may be drawn, cut out, and traced. Be sure each design has UNITY, VARIETY, AND EMPHASIS. It may also have RHYTHM OR MOVEMENT.

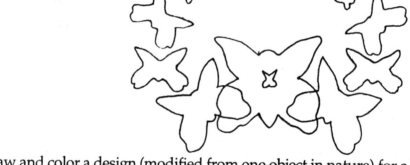

2. Draw and color a design (modified from one object in nature) for a NEW TYPE OF FURNITURE, CAR, BUILDING, CLOTHING, OR WALLPAPER.

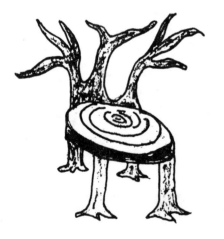
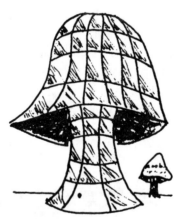

TREE CHAIR **MUSHROOM BUILDING** **LEAF WALLPAPER**

COLOR THEORY

EVERY COLOR HAS 3 QUALITIES:

1. The HUE or color itself
 (Color wheels are HUE CIRCLES)
2. VALUE OR BRIGHTNESS (Pink/red)
3. PURITY or SATURATION - brilliant
 & clean or drab

TINTS, TONES, AND SHADES:

1. TINT - combine white with a color. This changes brightness of the color.

2. TONE - combine a color with gray.

3. SHADE - combine a color with black - this changes its purity.

PRIMARY COLORS: RED, YELLOW, BLUE -
These colors make all other colors. White and black can also be mixed with them for other colors.

SECONDARY COLORS: ORANGE, GREEN, VIOLET -
Made by mixing 2 primary colors together. Mixing all 3 primary colors makes black.

TERTIARY COLORS: RED VIOLET, RED ORANGE, YELLOW ORANGE, YELLOW GREEN, BLUE GREEN, AND BLUE VIOLET -
Mix a primary color with a secondary color.

COMPLEMENTARY COLORS:
Colors opposite each other on a color wheel. When mixed together, they produce a neutral gray or black. They're good to use for purposes of contrast.

COLOR AND FEELINGS: WARM COLORS -
Yellow, red, and orange. These colors stimulate us and make people feel warmer and more cheerful.

COOL COLORS - Blue, green and violet.
These colors relax, calm, or depress us. Too much is "gloomy", but a little is very calming (used in doctor's offices).

EXAMPLES OF USE:
Green with envy, purple with rage, red with embarrassment, yellow with fear . . .

MONOCHROMATIC COLORS:
Have 1 color or hue with different values (shades, tints, or tones of 1 color).

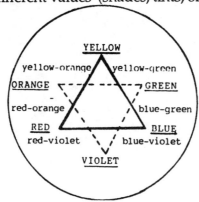

COLOR: KINDERGARTEN

CRAYON COLOR WHEEL

SUPPLIES: Pencil, paints & brushes, white and colored paper, scissors, glue, rulers, and compasses or round objects (for tracing), and crayons.

PROCEDURE:

REVIEW DESIGN UNIT AND COLOR THEORY ON PREVIOUS PAGES.

1. Review color wheels. Use only RED, YELLOW & BLUE crayons.

2. Have each child make a crayon color wheel as shown.

DESIGN USING PRIMARY COLORS

PROCEDURE:

1. Review color theory and design units.

2. Make a design using only primary colors. You may use paints or colored paper. Keep the design simple. Use no more than 3 shapes on the design. They may be various sizes, and overlapped when glued onto the paper. See sample below.

CRAYON COLOR WHEEL DESIGN USING PRIMARY COLORS

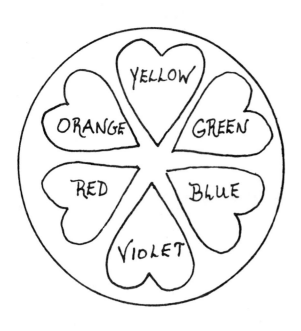

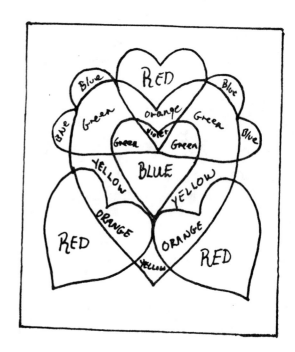

COLOR: 1ST GRADE

COLORED PENCIL COLOR WHEEL

SUPPLIES: Pencil, colored pencils, paints & brushes, rulers, and compasses.

PROCEDURE:

REVIEW DESIGN UNIT AND COLOR THEORY ON PREVIOUS PAGES.

1. Review color wheels. Use only RED, YELLOW, AND BLUE colored pencils.

2. Make a design using only the primary colors: RED, YELLOW, AND BLUE. Use tempera paint to mix the secondary colors where 2 primary colors overlap. 1 or more shapes may be drawn for the design. Be sure to draw some overlapping of the shapes. See examples below:

COLORED PENCIL COLOR WHEEL **PAINTED DESIGN**

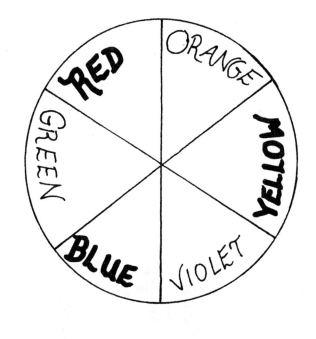
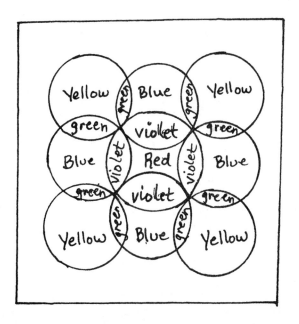

COLOR: 2ND GRADE

PAINTED COLOR WHEEL

SUPPLIES: Pencil, paints, brushes, mixing trays, white paper, markers, rulers, and compasses.

PROCEDURE:

REVIEW DESIGN UNIT AND COLOR THEORY ON PREVIOUS PAGES.

1. Review color wheels. Use only RED, YELLOW, AND BLUE paints.

2. Have each child make a painted color wheel as shown. Mix the primary colors to make the secondary colors.

DESIGN USING COMPLEMENTARY COLORS

PROCEDURE:

1. Review color theory and design units.

2. Students will draw and color a design using only 2 complementary colors: red/green, blue/orange, or yellow/violet. They can use markers or crayons.

3. Complementary colors are great to use for exciting designs with great contrast. (See example on 1st grade weaving also.) See example below:

PAINTED COLOR WHEEL

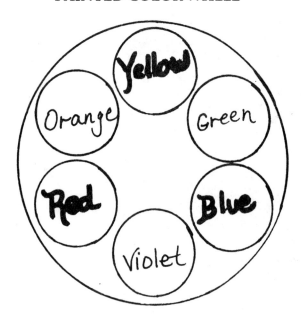

COMPLEMENTARY COLOR DESIGN

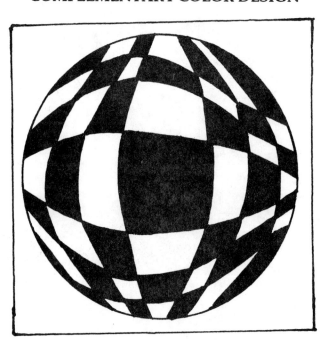

COLOR: 3RD GRADE

PAINTED COLOR WHEELS: PRIMARY, SECONDARY, & TERTIARY

SUPPLIES: Pencil, white paper, paints, brushes, mixing trays, rulers, and compasses.

PROCEDURE:

REVIEW DESIGN UNIT AND COLOR THEORY ON PREVIOUS PAGES.

1. Review color wheels. Use only RED, YELLOW, AND BLUE paints to make all the other colors.

2. Have each child make a painted color wheel as shown. Mix the primary colors to make the secondary colors. Mix one primary color with 1 secondary color to make the tertiary colors.

MONOCHROMATIC DESIGN OR PICTURE

PROCEDURE:

1. Student will draw and paint a monochromatic design or picture.

2. Give each child, or group of children: 1 color paint, white & black paint, and a mixing tray, and brushes.

3. Mix different shades or tints of 1 color for a great design or picture. See example below.

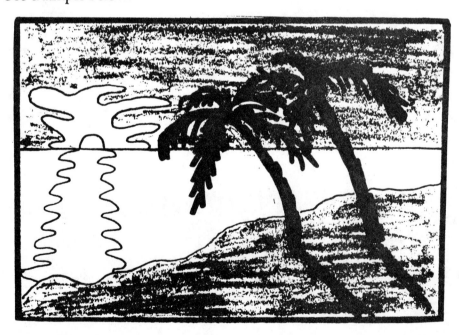

BLOCK LETTERING

This is block lettering. Each letter should be the same size and thickness. Use a ruler.

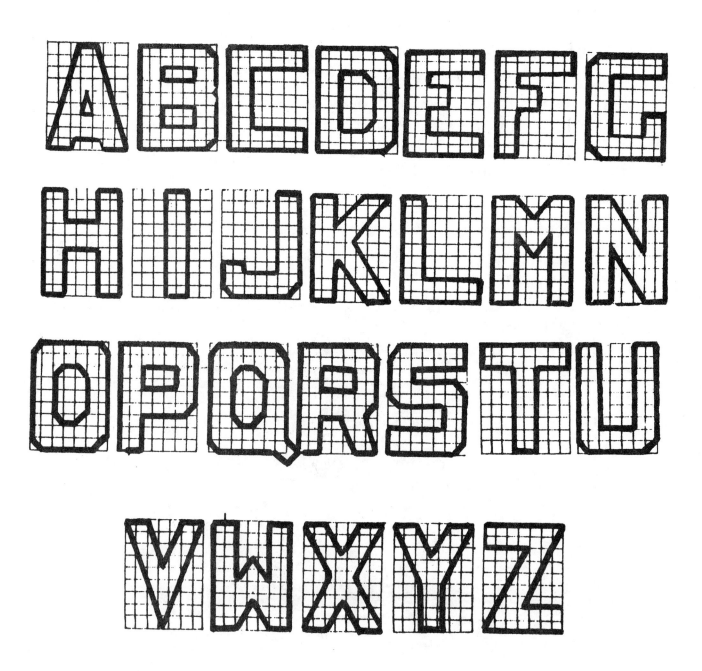

3D BLOCK LETTERING

This is 3D block lettering. Draw block letters first, and then make each letter 3D. Use a ruler.

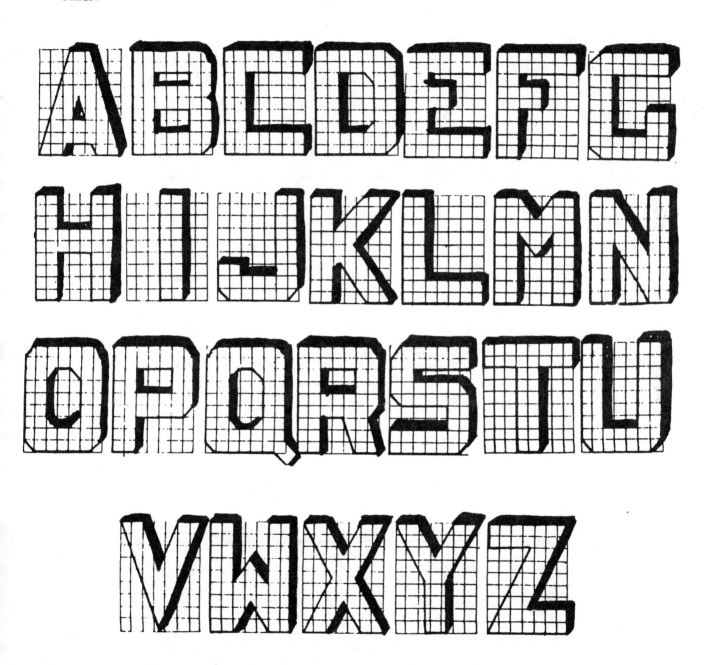

CALLIGRAPHY

This type of lettering is called calligraphy. A calligraphy pen and ink or calligraphy marker may be used. Follow the arrows, and try to make the strokes as smooth as possible.

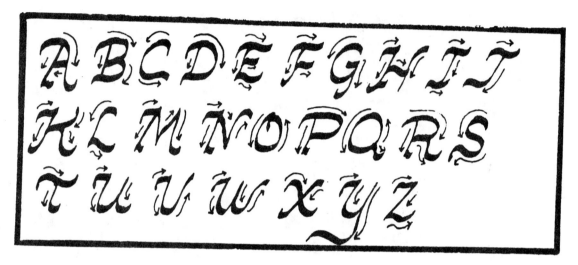

CRAYON TECHNIQUES

DRAWING

Experiment with different parts of the crayon: the tip, the blunt end, and an unwrapped side of the crayon. You can also experiment on different surfaces: white or colored papers, tissue paper, sand paper, wood, or tagboard.

CRAYON RUBBINGS

SUPPLIES: Objects to be rubbed: leaves, string, screening, corrugated cardboard, tombstones. . . , crayons, and white or colored papers. Tape may be used for smaller children.

PROCEDURE:

1. Place the object to be rubbed under a piece of paper, and press down firmly or tape the paper to the table.

2. Remove crayon wrapper, and rub gently back & forth until the crayon is making the lines & textures of the object beneath the paper.

3. Students can do the rubbings over & over again, and vary the position or colors used. Overlapping the rubbings is also very interesting.

CRAYON TECHNIQUES

CRAYON TRANSFERS

SUPPLIES: Pencil, crayons, and drawing paper.

PROCEDURE:

#1.

1. Fold drawing paper in half, and open it back up.

2. Color the entire left side as brightly as possible. (Don't draw a picture, just color the paper.)

3. Fold paper in half again, and draw a design or picture with a pencil. It can be made more interesting by making dots, stripes, or coloring in parts with a pencil.

4. Open up the paper to see the finished transfer. If more drawing is desired, repeat step #3.

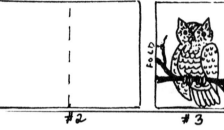

#2 #3 #4

MELTED CRAYONS

SUPPLIES: Pencil, crayons, iron, wax paper, wood, a cheese grater or popsicle sticks, newspapers, iron, paper, and scissors.

WOOD & CRAYON

PROCEDURE:

1. Draw with crayon on a piece of wood. Outline with a dark color if desired.

2. Cover with newspapers and iron to stain the wood.

GRATED CRAYONS

PROCEDURE:

1. Grate crayons with a cheese grater or popsicle sticks.

2. Place shavings between 2 pieces of wax paper, and iron.

3. These may be used for placemats, mobiles, . . .

WOOD & CRAYON **GRATED CRAYONS**

CRAYON TECHNIQUES

EMBOSSING

SUPPLIES: White paper, paint brushes, old magazines or newspapers, and assorted crayons.

PROCEDURE:

1. Put a piece of paper on top of an old magazine or stack of newspapers (for a cushion).

2. Use the tip of a paint brush handle to draw lines (a design or picture) as deeply as possible without tearing the paper.

3. Unwrap a light color crayon, and gently color the entire paper. Then go over the paper with a darker color. Experiment with mixing and layering various colors.

4. When finished, the invisible drawing will be "visible".

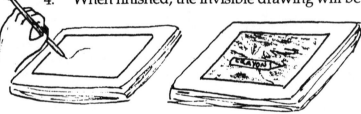

SCRATCHBOARD

SUPPLIES: White or manilla tagboard, brightly colored crayons, dark colored tempera paint, brushes, newspapers, soap, and a scratching tool (nail, paper clip, toothpick . . .).

PROCEDURE:

1. Color an entire piece of tagboard brightly with crayons.

2. Paint the entire paper with dark color tempera paint. You may need to rub the brush over a bar of soap so that the paint will adhere to the tagboard better.

3. Use a scratching tool to draw the picture. It may be scratched wet or dry.

CRAYON TECHNIQUES

RESISTS

SUPPLIES: Pencil, crayons, watercolor or tempera paints, brushes, newspapers, and white paper or tagboard.

PROCEDURE:

1. Draw a picture or design on paper or tagboard with a pencil.

2. Color with brightly colored crayons. Press down rather hard, and leave some spaces for the paint to show up. (Black areas on a butterfly, water in an underwater picture, or sky for an outer space picture.)

3. For good contrast, use dark paint over light crayon or light paint over dark crayons. Test a small area on the paper with paints. If the crayon doesn't show up you will have to color darker, or thin the paint with a little water.

4. When ready, paint the entire paper with watercolors or thinned down tempera paints.

PAPER BATIKS

SUPPLIES: The same as above.

PROCEDURE:

Steps #1 - 2 are the same, but use paper not tagboard.

3. Crunch up the paper, and open it back up.

4. Paint entire paper with watercolors or thinned temperas.

CRAYON RESIST EXAMPLE **PAPER BATIK EXAMPLE**

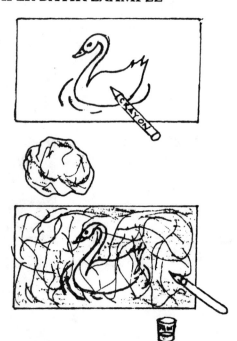

CRAYON: SUGGESTED ACTIVITIES

KINDERGARTEN

1. CRAYON RUBBINGS: Experiment with objects from nature. See previous pages for procedure.

2. EXPERIMENTAL DRAWINGS: Experiment using different parts of the crayon on white and colored papers. Use the tip, side, the opposite end ...

3. CRAYON RESISTS: Make beautiful resists using brightly colored or fluorescent crayons. Use light crayons/dark paint and dark crayons/light paint. See previous pages for techniques.

1ST GRADE

1. CRAYON TRANSFERS: See previous pages for procedure.

2. CRAYON RUBBINGS: Experiment with man made objects: string, corrugated cardboard, sandpaper, tombstones ... See previous pages for procedure.

3. PAPER BATIKS: Experiment with various types of paper for the batiks. Use brown paper bags, white, and colored papers. See previous pages for procedure.

4. CRAYON EMBOSSING: Experiment with embossing techniques. See previous pages for procedure.

CRAYON: SUGGEST ACTIVITIES

2ND GRADE

1. CRAYON STENCILS: Use stiff paper to cut out a stencil (shape). You may use the actual shape to trace around, or the hole itself.

2. SCRATCHBOARD: Make exciting scratchboard designs. Use bright or fluorescent crayons. Review design and crayon techniques.

3. CRAYON ON FABRIC: Draw with crayons on a t-shirt, pillow case, handkerchief, or fabric scrap. You can buy special "fabric crayons" that work great. When finished drawing, simply place newspapers over and under the fabric. If using a t-shirt, place newspapers inside it too. After all the wax is ironed out of the fabric, it's finished. Be sure to change newspapers as they get dirty.

3RD GRADE

1. WOOD & CRAYON: Make beautiful plaques, door signs, or wall hangings. Simply color on a piece of wood, and cover with newspapers. Iron the wax out, but be sure to change the papers as they become dirty.

2. SCRATCHBOARD DRAWINGS: Make beautiful scratchboard drawings, such as still life, animal, scenery, butterfly.... Review procedure on the previous page.

3. GRATED CRAYONS: Grated crayons, melted between layers of wax paper, can be used for beautiful mobiles, flowers, placemats, wall hangings, or other uses. See procedure on previous pages.

FINGERPAINTING - HOW TO USE FINGERPAINTS

SUPPLIES: Fingerpaint paper, fingerpaints, sink full of water or bucket of water, bowls of water at tables, pencil, lots of newspapers, and smocks for each child to wear.

PROCEDURE:

1. Spread out newspapers on tables where children will be fingerpainting. Give each child a fingerpaint paper, and put name on the back, not on the shiny side.

2. Fill a bucket or sink full of water.

3. Let each child completely soak her paper with water, and take the paper to the painting table.

4. Spread the fingerpaint paper out with the shiny side up, and gently smooth. (This paper should be on top of several layers of newspapers.)

5. Put approximately 1 tbsp. of fingerpaints on the middle of the paper, and gently smooth it out over the entire paper. Don't apply paint too heavily, or it will crack off. If the paint doesn't spread around very well, a few drops of water may be added and blended in.

6. Once the entire paper is covered with a thin coat of paint, different parts of the forearm or hand may be used. For example:

 Side of the hand
 Closed fist
 Bent fingers
 Open palm
 Wrist
 Heel of the hand
 Knuckles
 Fingernails
 Or objects: combs, cardboard, ...

 (If the paper starts to dry, just wet your fingers with a few drops of water.)

7. When the child is happy with the composition, let the painting dry flat on newspapers.

8. When the painting is dry, it can be pressed flat under several books, or ironed with a warm iron on the back side, with newspapers underneath.

SOME IDEAS FOR FINISHED FINGERPAINTINGS:

Covered with contact paper for placemats or book covers, a vase for dried or tissue paper flowers (rolled up and glued), as a painting or background painting in which other objects are glued onto it, or as background paper for masks, hats, puppets...

ANY SMOOTH PAPER, SUCH AS TAGBOARD MAY BE USED TO PAINT ON

FINGERPAINTING: KINDERGARTEN

FINGERPAINTING PROJECT IDEAS: USE 1 PRIMARY COLOR ONLY: RED, YELLOW, OR BLUE.

REVIEW PROCEDURE DIRECTIONS ON THE 1ST PAGE OF THE FINGERPAINTING UNIT.

SUPPLIES: Fingerpaint paper, fingerpaints, sink or bucket of water, bowls of water at painting tables, pencil, lots of newspapers, and smocks for each child to wear.

PROCEDURE:

BE SURE TO REVIEW THE COLOR AND DESIGN UNITS.
See the previous page.

1. After the surface is covered with a thin, smooth coat of paint, make DESIGNS USING REPETITION OF 1 SHAPE. Repeat the same shape several times using the tip of the finger, fingernail, palm, wrist, knuckle, or even an object, such as a piece of cardboard, a vegetable, an eraser, or a piece of styrofoam.

2. After the surface is covered with a smooth coat of paint, make a picture of an exciting face: a king, queen clown, alien, robot . . . Have fun!

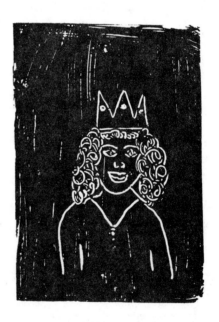

FINGERPAINTING: 1ST GRADE

FINGERPAINTING PROJECT IDEAS: USE 2 PRIMARY COLORS: RED, BLUE OR YELLOW ONLY.

SUPPLIES: Fingerpaint paper or another smooth shiny paper (such as tagboard), fingerpaints, sink or bucket of water, bowls of water at painting tables, pencil, lots of newspapers, and smocks for each child to wear.

PROCEDURE: Review COLOR and DESIGN UNITS.

See previous pages for fingerpainting procedures and suggestions.

1. After the surface is covered with a smooth coat of paint, make DESIGNS USING REPETITION OF MORE THAN 1 SHAPE. Repeat 2 or more shapes into an interesting pattern or design. Use parts of the hand or other objects, such as spools, erasers, sticks, cardboard, vegetables, clay . . .

2. On another paper, cover 1/2 with 1 PRIMARY COLOR & 1/2 WITH ANOTHER PRIMARY COLOR. Experiment with blending the 2 primary colors to make secondary colors. Draw an interesting picture, such as a huge tree with lots of leaves, an outer space scene.

DESIGN USING REPETITION

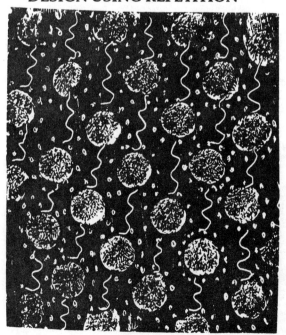

TREE SCENE

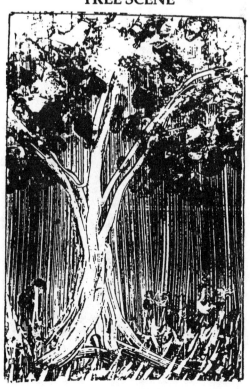

FINGERPAINTING: 2ND GRADE

FINGERPAINTING PROJECT IDEAS: USE 2 PRIMARY COLORS: RED, BLUE, OR YELLOW ONLY.

SUPPLIES: Fingerpaint paper, fingerpaints, sink or bucket of water, bowls of water at painting tables, pencil, lots of newspapers, and smocks for each child to wear.

PROCEDURE:

BE SURE TO REVIEW THE COLOR & DESIGN UNITS REVIEW PROCEDURE DIRECTIONS ON THE 1ST PAGE OF THE FINGERPAINTING UNIT.
See previous pages.

1. After the surface is covered with water and smoothed out, make a DESIGN USING REPETITION OF 2 OR MORE SHAPES, BUT THIS TIME, ALSO VARY THE SIZES OF THE SHAPES. Use parts of the hand or other objects.

2. Cover part of the paper with 1 PRIMARY COLOR AND OTHER PARTS WITH ANOTHER PRIMARY COLOR. Experiment to make secondary colors, such as orange, green, or violet. Draw an interesting picture, such as a storm on the sea with a ship on the water, or EXPERIMENT WITH TEXTURES. Draw a bird, fish, or animal, and show each feather, scale, or hair.

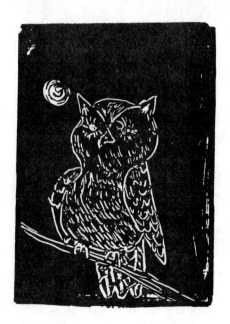

FINGERPAINTING: 3RD GRADE

FINGERPAINTING PROJECT IDEAS: USE ALL 3 PRIMARY COLORS: RED, YELLOW, AND BLUE.

SUPPLIES: Fingerpaint paper, fingerpaints, sink or bucket of water, bowls of water at painting tables, pencil, lots of newspapers, and smocks for each child to wear.

PROCEDURE: BE SURE TO REVIEW THE COLOR AND DESIGN UNITS. REVIEW PROCEDURE DIRECTIONS ON THE 1ST PAGE OF THE FINGERPAINTING UNIT.
See previous pages.

1. EXPERIMENT WITH TEXTURES FOR THIS PAINTING. EXPERIMENT WITH COLORS ALSO. Make a quilt painting with various boxes, such as a patchwork quilt. Fill each box with interesting textures and colors. Mix 2 primary colors together to make secondary colors. Be sure to REPEAT TEXTURES AND COLORS IN THE DESIGN.

2. EXPERIMENT WITH TEXTURES AND COLORS FOR THIS PAINTING. Paint an exciting picture with lots of different textures such as a still life with many different textures and colors, or an underwater picture with different textures for the sand, fish, grasses, seahorses . . .

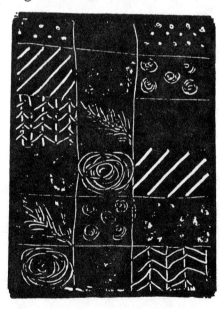
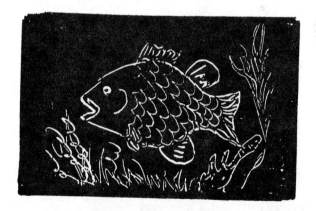

WATERCOLOR TECHNIQUES

WET ON WET: This technique uses wet paint on wet paper. It works great for large areas such as skies, lakes, or large background areas.

WET ON DRY: This technique uses wet paint on dry paper. It works well on smaller areas such as buildings, roads, hills, or mountains.

DRYBRUSH: This technique uses a dried off paint brush on dry paper. This is done by putting wet paint on a brush and wiping the brush on newspaper until the excess paint and water come off. The brush will then make nice thin lines which are great for painting small details. Animal fur, feathers, individual grasses, trees, tree bark, cat tails, and fences work great using the drybrush technique.

PAINTING SKY: Use the wet on wet technique, painting the top of the sky darker than the rest of the sky. Blue, blue and violet, or red, orange, and yellow, are good colors for skies.

PAINTING TREES IN THE BACKGROUND: While the sky is still wet, turn the paper upside down, and dab green and brown paint along the horizon line. The paint will spread a little to form tree shapes.

PAINTING A BACKGROUND: Use the wet on wet technique for very large areas.

PAINTING A RIVER: Wet the river with water and immediately paint with a blue-green color. If it's too dark, blot with a paper towel.

PAINTING A LAKE: Wet the lake with water and paint with a blue-green color. If there is a sunset, carefully paint a yellowish orange color. If it's too dark, blot with a paper towel.

WATERCOLOR TECHNIQUES

PAINTING BARNS OR OTHER BUILDINGS: Use the drybrush technique to show texture on the buildings. Be sure to show one side in shadow and a shadow on the ground.

PAINTING FENCES: Use the drybrush technique, and blot if it's too dark. Be sure to show cast shadows on the ground.

PAINTING ANIMALS, CAT TAILS, AND OTHER SMALL DETAILS: Use the drybrush technique. Mix colors together to add more variety to the picture. For example, use green, yellow, and brown colors in the grass.

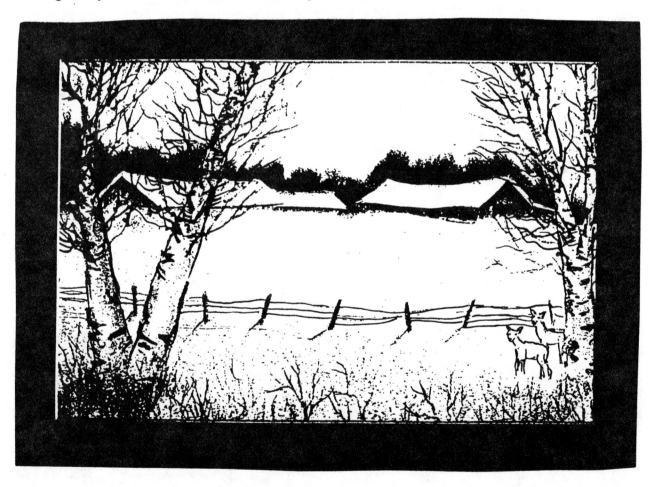

WATERCOLOR: K - 3 SUGGESTED ACTIVITIES

REVIEW PREVIOUS PAGES FOR WATERCOLOR TECHNIQUES

KINDERGARTEN

1. WATERCOLOR SCENE: Paint a scene with sky, land, and trees that are bled into the sky. (Turn paper upside down to paint trees.)

2. WATERCOLOR SELF PORTRAIT: Paint a portrait of yourself using watercolors. Review portrait techniques.

1ST GRADE

1. WATERCOLOR SCENE WITH A BIG TREE WITH BRANCHES: Review tree drawing techniques. Paint a scene first. When dry, draw and paint a big tree with branches using a drybrush technique, so that you are able to make nice, thin branches.

2. WATERCOLOR CLOWN PORTRAIT: Review portrait techniques. Draw and paint a clown's portrait.

2ND GRADE

1. WATERCOLOR SCENE WITH A HOUSE OR BARN: Draw and paint the picture. Paint the barn and other drybrush details last.

2. WATERCOLOR PAINTING OF YOUR TEACHER: Review portrait and figure drawing techniques. Draw and paint the portrait or the entire body of your teacher.

3RD GRADE

1. WATERCOLOR NIGHT SCENE WITH A BUILDING: Review 3D building and tree techniques. Use yellow or white crayons to color stars or windows, then go ahead and paint the rest of the picture. The crayon will show through the watercolors, like light shining in the night (crayon resist).

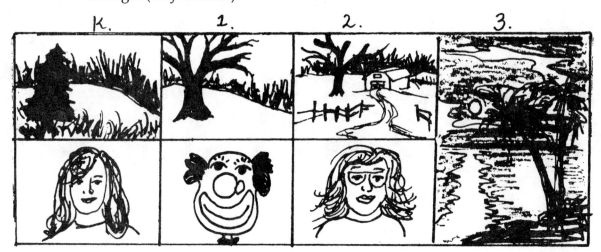

PAPER MACHE' TECHNIQUES

PROCEDURE:

PAPER MACHE' IS AN INEXPENSIVE, VERSATILE MATERIAL. PUPPETS, MASKS, ANIMAL OR OTHER SCULPTURES, RELIEF MAPS, AND JEWELRY ARE JUST A FEW THINGS THAT CAN BE MADE USING PAPER MACHE'.

1. An armature of foundation must first be made out of any of the following: crunched up or rolled newspapers, aluminum foil, balloons, modeling clay, cardboard, cardboard tubes, wire, chicken wire, styrofoam, boxes, or any other "found objects". Make sure that the structure or armature is put together well. Use tape or a glue gun to put parts together.

2. Mix the paper mache' paste that you will be using. You can mix wallpaper paste, wheat paste, or flour with water until a smooth pudding like consistency is achieved.

3. Tear or cut newspapers into strips. The strips should be thin for small objects, and wide for larger objects.

4. Dip the newspaper strips, one by one, into the paste mixture. Be sure to completely coat both sides of the newspaper strips.

5. Apply 2-3 coats of newspaper strips to the armature.

6. Apply a final coat of white or manilla paper towels, which have been cut into strips and dipped into the paste mixture.

7. Let dry for several days.

8. Paint with acrylic or tempera paints. If using tempera paints, spray varnish over the finished painted objects. Construction paper or fabric may be glued onto the finished figure.

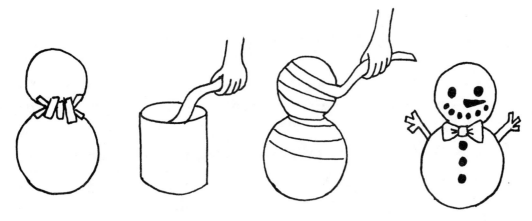

PAPER MACHE': SUGGESTED ACTIVITIES

KINDERGARTEN

PAPER MACHE' BOWL

PROCEDURES: REVIEW PREVIOUS PAGE

1. Bring a bowl for each student, and cover the outside with a thin coat of vaseline (to keep paper mache' from sticking to the bowl).

2. Place the bowl upside down, on newspapers, and begin covering the bowl with strips of paper mache'.

3. Apply 3-4 coats, let dry, then remove and paint.

1ST GRADE

PAPER MACHE' OVER AN INFLATED BALLOON

1. Blow up a balloon, and apply 3-4 coats of paper mache' strips. Be sure to overlap each strip.

2. Let dry thoroughly, and paint as desired. They can be used for large masks, small puppets, globes, or . . .

2nd GRADE

FIGURES THAT ARE BUILT AROUND LIQUID DISH DETERGENT BOTTLES

1. Use a liquid dish detergent bottle for the body of a person, and use a piece of newspaper, which has been crunched up into a ball, for the head. Arms can be made from cardboard tubes or rolled up newspapers. Be sure to attach all body parts securely to the bottle.

2. Apply 3-4 coats of paper mache' strips to the armature.

3. Let dry thoroughly, and paint as desired.

3RD GRADE

CARDBOARD & PAPER MACHE' ANIMAL HEADS OR FISH

1. Use a stiff cardboard or piece of wood for the base of the paper mache' wall hanging.

2. Attach an armature for the animal to the base. Use newspapers, cardboard, or balloons for the armature. Make a fish or an animal head. The mouth can be open, with cardboard teeth. Be sure to attach the armature securely.

3. Apply 3-4 coats of strip paper mache' to the armature and board or cardboard.

4. Let dry completely, and paint as desired.

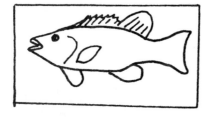
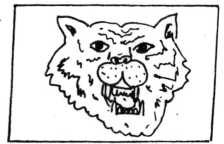

MASKS: PAPER BAG MASKS - KINDERGARTEN

SUPPLIES: Pencil, large paper bag, tempera paints, brushes, colored construction paper, scissors, glue, crayons or markers, fabric and yarn scraps.

PROCEDURE:

1. Trim shoulder openings on both smaller sides of the paper bag as shown below. Cut the openings 6" - 8" up from the bottom of the bag, (with the bag turned upside down) until it fits the child's body.

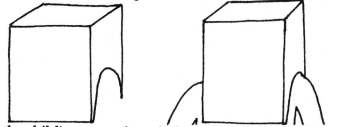

2. Locate the child's eyes and mark them with a crayon. Remove the bag and cut out eye openings.

3. Decorate the bag with any of the listed materials. Hats, ears, hair, noses, mouths, crowns, or any other materials may be added.

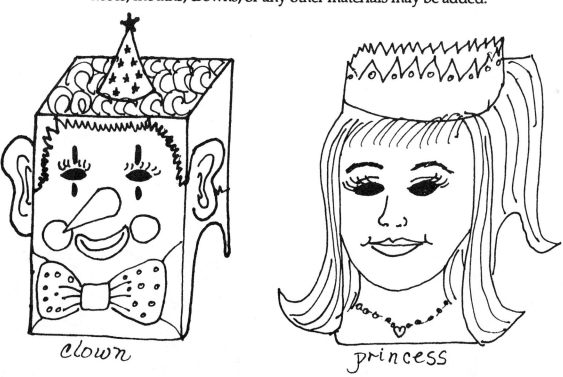

clown princess

MASKS: PAPER MACHE' - 1ST GRADE

SUPPLIES: Paper mache' flour, wheat paste, wallpaper paste, or regular flour and water, newspaper strips cut into 1" thick strips, newspapers, paints & brushes, pencils, vaseline, buckets, and yarn, fabric, or paper scraps. Scissors, glue, a glue gun (to be used by an adult), and some inexpensive plastic face molds. These are inexpensive and can be purchased from any large company which sells school or art supplies.

PROCEDURE: Review the paper mache' unit, pages 71 and 72.

1. Give each child a face mold, strips of newspapers, and a bowl of paper mache' paste. Cover the tables with newspapers. Coat the front of masks with vaseline.

2. Dip newspaper strips, one at a time, into the mixture. Smooth the mixture on both sides of the strip.

3. Apply 2 coats of newspaper strips to the mask. Try to overlap the strips so that the mask will be sturdy.

4. Apply a final coat of white or manilla paper towel strips. This will make the painting easier.

5. Let dry completely.

6. Cut out eye holes, and paint as desired. Tempera or acrylic paint works great.

7. Other details, such as: yarn hair, fabric or paper details, may be glued onto the mask.

8. A piece of yarn may be attached to both sides of the mask, if desired.

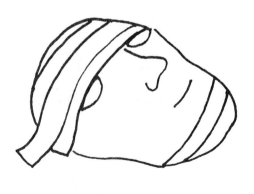
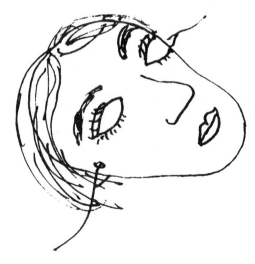

MASKS: PAPER PLATE MASKS - 2ND GRADE

SUPPLIES: Pencil, scissors, glue, crayons or markers, paints, brushes, yarn, fabric & paper scraps, and paper plates.

PROCEDURE:

1. Hold a paper plate up to the child's face.

2. Mark eyes, bottom of nose, and mouth with a crayon.

3. Cut out eye and nose openings as shown below. An opening for the mouth or tongue may be cut also.

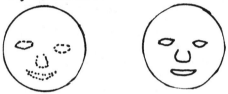

4. Draw details on the face of the mask. Some ideas are: animals, clowns, people, monsters.....Details may be drawn on or painted on the plate. Yarn, fabric, or paper scraps may also be added.

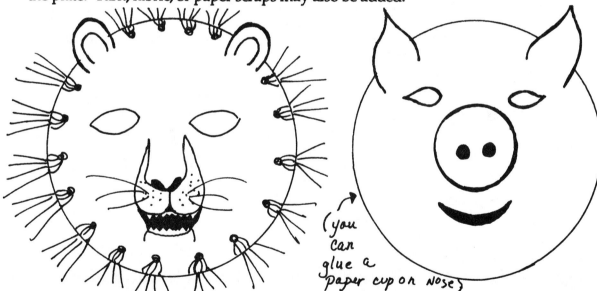

(you can glue a paper cup on nose)

5. Attach yarn to each side of the mask with glue, tape, or with a hole punch and knot.

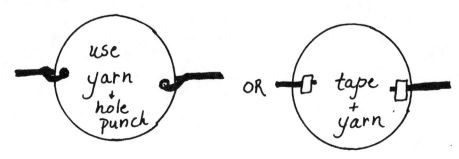

use yarn + hole punch

OR

tape + yarn

MASKS: SUNGLASS MASKS - 3RD GRADE

SUPPLIES: Pencil, scissors, glue, tagboard, colored cellophane, markers or crayons, colored paper, yarn or fabric scraps, paint, and brushes.

PROCEDURE:

1. Give each child a 9 x 12 piece of tagboard (white, manilla, or a color).

2. Hold the tagboard horizontally up to the child's face, and mark the eyes and bottom of the nose with a pencil or crayon.

3. Cut out the eye and nose openings as shown.

4. Finish drawing the rest of the mask sunglasses. Some ideas are: Imaginary people or animals, birds, clowns, outer space people, bugs . . .

5. Color or paint the mask. Colored paper, fabric, or yarns may also be added. Feathers, pom poms, or any other materials you may have may also be used.

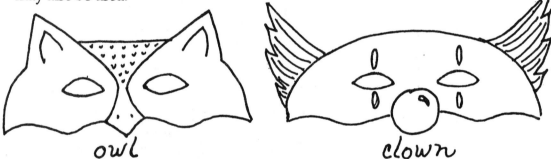

owl clown

6. Glue or tape colored cellophane to the back of the eye openings.

7. Attach yarn or string elastic to sides of the mask. You can use a hole punch and knot or strong tape.

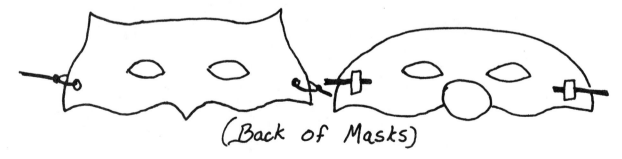

(Back of Masks)

PUPPETS: CRUNCHED UP PAPER BAG ON A STICK - KINDERGARTEN

SUPPLIES: Pencil, small paper lunch bags, stick or dowel rod, newspapers to stuff the bag, colored paper, yarn, fabric scraps, scissors, glue, tempera paint, brushes, markers, or crayons.

PROCEDURE:

1. Fill the lunchbag with small pieces of newspaper.

2. Insert a stick into the bag until it touches the bottom. Squeeze the open end of the bag around the stick, and tie a piece of yarn tightly to form a neck. (Leave enough stick at the bottom for a handle.)

3. Features on the puppet may be added with the above listed materials. Some ideas are: farm or zoo animals, dinosaurs, cartoon characters, or characters for a classroom play. Any seasonal idea, such as bunnies, Santa, pilgrims, witches . . . would also work well.

4. A circular piece of fabric with a small hole in the center may be added for clothes. Rubber band or tie the fabric on the stick.

SPOON PUPPET

SUPPLIES: 1 spoon per child, cotton balls, glue, scissors, and paper scraps. Fabric, yarn, or markers can be used too.

PROCEDURE:

1. Features for puppets can be drawn on the back of spoon with markers, or a piece of paper that has been glued to a cotton ball (which has been glued to a spoon).

2. Fabric, yarn, or paper scraps can be added.

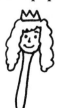
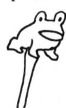

PUPPETS: FINGER AND TUBE PUPPETS - 1ST GRADE

2 FINGER PUPPETS

SUPPLIES: Pencil, 4 x 6 pieces of tagboard, crayons, colored pencils, or markers, and scissors.

PROCEDURE:

1. Give each child a 4 x 6 piece of tagboard. Have them draw a person or animal as large as the paper. (See examples.)

2. Draw 2 holes for the fingers by tracing the scissors holes.

3. Color the puppet, and cut out the finger holes and around the outside of the puppet.

4. Have fun with the puppet. You can put the index and middle fingers in the puppet for legs.

TUBE PUPPETS

SUPPLIES: Pencil, scissors, glue, paper or fabric scraps, yarn, a sock for each child (optional), and a toilet tissue roll for each child. Paints & brushes are optional.

PROCEDURE:

1. Give each child a tissue roll for the puppet's head. A stiff piece of paper can be glued across the top opening of the tube. When dry, it can be trimmed.

2. The puppet can be decorated with any of the above listed materials or others you may have. Ears or hair may be glued on. Faces may be colored, painted, or glued on with paper or fabric scraps.

3. The body of the puppet can be made from a sock. Put the sock on the child's hand, and open the hand. Put the sock on the child's hand, and open the hand. Wiggle the little finger and thumb, and cut a tiny hole where they touch the sock. This will be the arms for your puppet.

4. Put the sock on the child's hand, putting the thumb and little fingers in the holes, and put the puppet head (roll) on the other 3 fingers.

PUPPETS: TUBE - 2ND GRADE

SUPPLIES: Pencil, scissors, glue, stapler, 9 x 12 white or colored paper or tagboard, colored paper or fabric scraps, yarn, and sequins, buttons, foil, or anything else to decorate the puppet.

PROCEDURE:

1. Roll a 9 x 12 paper ino a cylinder or cone shape. Glue or staple it together to hold its shape. It can be trimmed if necessary.

2. Decide what type of puppet to make: man, woman, child, king, queen, animal. Use any of the mentioned materials to decorate the puppet. Paper may be folded, curled or braided too. Eyelashes and hair can be curled around a pencil and glued on, or yarn may be used.

3. Attach a small paper tube that fits over the child's middle finger to the inside of the puppet with tape or glue.

4. A body may also be added with paper or fabric.

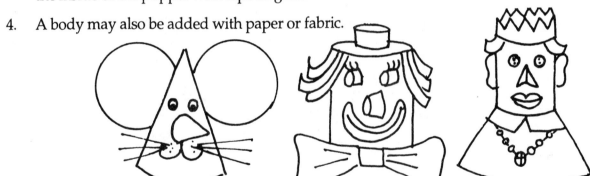

A VARIATION USING MULTI STRIP TUBES

PROCEDURE:

1. Roll a paper tube from 6 x 9 paper for the body. Secure the roll with glue or tape.

2. Make smaller paper tubes for the head, ears, legs, or arms. Attach them to the body with tape or glue. Details may be drawn or glued onto the puppet.

childs arm goes here →
or
here ↘

PUPPETS: PAPER BAG HAND PUPPETS - 3RD GRADE

SUPPLIES: Pencil, small paper lunch bags, colored paper, fabric, yarn scraps, scissors, glue, stapler, markers, or crayons.

PROCEDURE:

1. Turn the bag inside down and draw the eyes and nose on the bottom of the bag as shown. Some ideas are: seasonal characters, wizards, kings.

2. Attach fabric, colored paper, or yarn for details on the puppet. Paper may be rolled or braided. Yarn may be braided or stapled on. Hats, hair, lips, or any other details may be glued or stapled on.

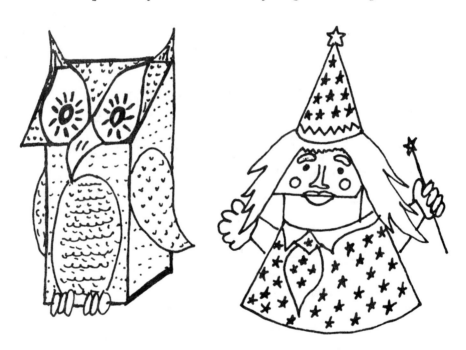

PRINTMAKING: SURFACE PRINTING - KINDERGARTEN

THIS IS ALSO CALLED PLANOGRAPHIC PRINTING

OBJECT PRINTS

SUPPLIES: Pencil, paper, an inked stamp pad, crayons, colored tempera paints, brushes, newspapers, objects to print, possibly a printing pad (directions below).

PROCEDURE:

1. Students will need objects to print: leaves, coins, nuts, seeds, clothespins, marker caps, pieces of carrots.

2. To make a printing pad: Cut newspapers (about 20 thicknesses) for a printing pad (5 x 7 or larger). Saturate with water, and sprinkle wet or dry tempera paint on the newspapers. Blend with a brush if needed.

3. Apply paint to objects and press on a background paper in any desired pattern or design. Paint may be painted on object with a brush or use the printing pad. An inked stamp pad may also be used.

FINGERPRINTS

SUPPLIES: Fingers, paper, and printing pads or inked stamp pads. Crayons or markers, and pencils may be used for finishing.

PROCEDURE:

1. Students will print their fingerprints on a piece of paper, making an exciting design or picture. It's a good idea to use only 1 finger and wash immediately when done printing.

2. Students can draw pictures from the fingerprints. See examples.

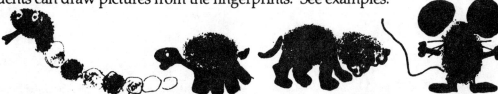

PRINTS MAY BE USED FOR GREETING CARDS, PLACEMATS, WRAPPING PAPER, NOTE PAPER OR CARDS, BOOK COVERS, INVITATIONS, VASES. . . .

PRINTMAKING: STENCIL PRINTS - 1ST GRADE

THIS TYPE OF PRINT HAS THE PART TO BE PRINTED CUT OUT OF ANOTHER SURFACE. THIS IS CALLED A STENCIL.

SUPPLIES: Pencil, scissors, stiff brushes, stencil paper or other stiff paper, and tempera paints. This process may also be used with colored chalks on white or colored paper. White or colored paper or tissue papers may be used to print the design on.

PROCEDURE:

1. With a pencil, draw a simple shape on the stencil paper. This may be done on small pieces of stencil paper or stiff paper, about 4 x 4.

2. Cut out the shape. (Paint around the shape - negative print.)

3. Put tempera paints into small bowls, and put some paint on a stiff brush. Hold the stencil paper down on top of another paper, and paint the open shape (positive).

4. Repeat as desired. Be careful not to smear the paint.

IF USING CHALK: SIMPLY DRAW WITH THE CHALK TOWARD THE CENTER OF THE OPEN SHAPE. SEE EXAMPLES BELOW.

POSITIVE STENCIL DESIGN

NEGATIVE STENCIL DESIGN

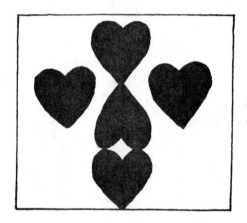 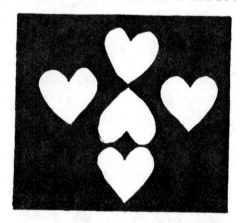

THIS PROCESS MAY ALSO BE DONE WITH CLOTH, CARDBOARD, OR ON A SILK SCREEN.

PRINTS MAY BE USED FOR GREETING CARDS, PLACEMATS, WRAPPING PAPER, NOTE PAPER OR CARDS, BOOK COVERS, INVITATIONS, VASES . . .

PRINTMAKING: INTAGLIO PRINTS - 2ND GRADE

THIS TYPE OF PRINT HAS PART OF THE SURFACE CUT AWAY. THE INK IS THEN PRINTED FROM THAT SURFACE.

SUPPLIES: Pencil, toothpicks or nails, bars of soap or modeling clay, paper, and moist tempera paint and brushes, or a painting pad, or a brayer and water base ink, and newspapers.

PROCEDURE:

1. If using soap: draw a design or drawing with a sharp object, such as a pencil, nail, or toothpick. If putting words on the object, they must be written backwards.

2. If using modeling clay: make a small ball about the size of a tennis ball. Flatten 1 end on the table, and form the rest of the clay into a type of handle to hold. Draw the design or drawing on the flat part of the clay with a sharp object. If putting words on the clay, they must be written backwards.

3. Ink the clay or soap using tempera paints, a printing pad, or waterbase ink and a brayer. To make a printing pad: cut newspapers (about 20 thicknesses) for a printing pad (5 x 7 or larger). Saturate with water and sprinkle wet or dry tempera paints on the paper. Blend with a brush if needed.

4. Stamp design on the desired background. Repeat as needed. Re-ink when necessary.

THIS PROCESS MAY ALSO BE DONE WITH: STYROFOAM, PLASTER, OR WAX.

PRINTS MAY BE USED FOR GREETING CARDS, PLACEMATS, WRAPPING PAPER, NOTE PAPER OR CARDS, BOOK COVERS, INVITATIONS, VASES. . .

PRINTMAKING: RELIEF PRINTS - 3RD GRADE

THIS TYPE OF PRINT HAS PART OF THE SURFACE CUT AWAY.

SUPPLIES: Paper, moist tempera paint & brushes or a painting pad, carrots or potatoes, and scratching or carving tools: scissors, nails, a nail file, toothpicks, or a blunt knife.

PROCEDURE:

1. Give each child a potato or carrot half and a carving tool.

2. Have students carve a design on the flat part, and cut part of the potato or carrot away. See examples.

3. Apply paint: paint it on with a brush or use a printing pad. To make a printing pad: cut newspapers (about 20 thicknesses) for a printing pad (5 x 7 or larger). Saturate with water, and sprinkle wet or dry tempera paints on the papers. Blend with a brush if needed.

4. Stamp design on the desired background. Repeat as needed. Re-ink when necessary.

CARROT PRINTS

PRINTS MAY BE USED FOR GREETING CARDS, PLACEMATS, WRAPPING PAPER, NOTE PAPER OR CARDS, BOOK COVERS, INVITIATIONS, VASES. . .

THIS PROCESS MAY ALSO BE DONE WITH: WOOD, CARDBOARD, FABRIC, LINOLEUM, OR OTHER MATERIALS.

WEAVING: PAPER WEAVING - KINDERGARTEN

SIMPLE STRAIGHT PAPER WEAVING

SUPPLIES: Pencil, ruler, scissors, glue, colored and white construction paper.

PROCEDURE:

1. Give each child 2 pieces of paper that are not the same color: black & white, orange & blue, purple & yellow, or any others. Fold 1 paper in half, draw lines with a ruler, and cut as shown. Precut 1" strips and give 10 of them to each child (if using 9 x 12 paper) or 16 strips (if using 12 x 18 paper).

2. Have students start at one end, and weave the strips from one side to the other as shown.

3. When finished weaving all strips, glue all loose ends.

PAPER WEAVING SHAPES

SUPPLIES: Pencil, ruler, scissors, glue, colored and white construction paper.

PROCEDURE:

1. 1 piece of paper can be drawn into a shape and cut out: hearts, pumpkins, birds, hats, shamrocks, . . .

2. Draw a line 1" from the bottom and 1" from the top of the shape. Draw 1" lines from the top line to the bottom line as shown.

3. Weave 1" paper strips into the cut out shape. Glue when finished.

WEAVING: OPTICAL ILLUSIONS - 1ST GRADE

SUPPLIES: Pencil, scissors, glue, ruler, white and colored construction paper.

PROCEDURE:

1. Give each student black & white paper or 2 complementary colors of paper, such as: orange & blue, yellow & violet, or red & green. Using these color combinations will make the "Optical Illusions" more exciting.

2. Draw a line with a ruler that is 1" from the bottom and 1" from the top of the paper (on either paper).

3. Draw curved lines from the top line to the bottom line as shown. Cut these lines, but stop when you hit the top and bottom lines (which were drawn first). See example.

4. With the other paper, cut curved pieces, only 1 at a time, and weave across the other paper. Glue when finished.

WEAVING: SODA STRAW LOOM - 2ND GRADE

SUPPLIES: Soda straws, assorted yarn, scissors.

PROCEDURE:

1. Students can make bookmarks or belts using soda straws for a loom.

2. Give each student 4-6 soda straws and the same number of pieces of yarn, about 2' long each. They must be much longer if making a belt (6').

3. Tie a small piece of yarn to the center of each piece of yarn, and pull 1 piece of yarn through each straw as shown. One end should have two loose pieces of yarn, and the other end of the straw should have a loop.

4. With a piece of yarn (about 6" long), tie all the loose ends together for a tassle.

5. Start weaving with another piece of yarn, and be sure to hold the straws togehter. When you weave from 1 side to the other side of straws, simply wrap the yarn around the straw, and start weaving across in the other direction. See example.

6. To change colors of yarn, simply tie the new color yarn in a knot with the old color yarn.

7. When finished weaving, slip the straws off the yarn, and tie another tassle. When the straws are about 3/4 covered with weaving, you can slide the weaving down, so that only about 1/4 of the straw is covered with weaving.

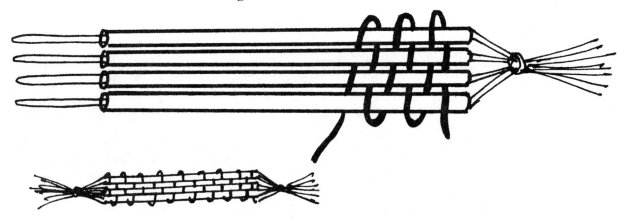

WEAVING: A WOODEN LOOM - 3RD GRADE

SUPPLIES: 4 pieces of wood per loom, approx. 1" x 2" wide, hammer, pencil, yarn, finishing nails, and scissors, and a ruler. Or you can make cardboard looms with stiff cardboard.

TO CONSTRUCT THE LOOM

PROCEDURE:

1. Arrange 4 pieces of wood into a rectangle, with the shorter pieces nailed to the top of the longer pieces.

2. Draw dots at 1/2" intervals on each short piece of wood. Nail finishing nails where each dot is, but only drive them in half way. Now the loom is ready to weave.

TO WEAVE THE LOOM

PROCEDURE:

1. Tie the yarn to any corner nail, and string it down the entire length of the rectangle to the nail directly opposite it. Wrap the yarn around 2 nails, and go back the opposite direction to the next empty nails. Continue doing this until all nails are wrapped. Tie in a knot to the last nail, cut the yarn, and begin the weaving process. See example below.

2. Tie the yarn to the first nail, and begin weaving across the loom as shown. When finished, remove from the loom.

WOODEN LOOM **CARDBOARD LOOM** **WEAVING THE LOOM**

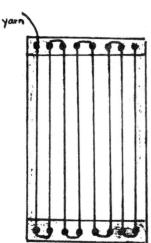
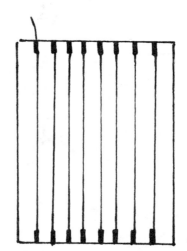
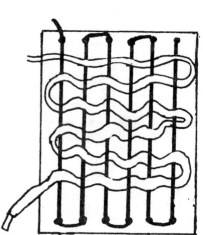

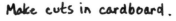
Make cuts in cardboard.

HATS: CROWNS AND CLOWN HATS - KINDERGARTEN

SUPPLIES: Pencil, scissors, glue, 12 x 18 white or colored paper, and crayons, markers, or paint and brushes to decorate the hats. Fabric pom poms, foil, or sequins may also be used.

CROWNS

PROCEDURE:

1. Cut 12 x 18 paper into 6 x 18 strips, one per child.

2. Cut a crown out as shown, and decorate as desired.

3. Hold the crown up to child's head, and glue to fit.

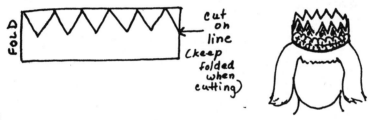

CLOWN HATS

PROCEDURE:

1. Fold a 12 x 18 piece of paper as shown.

2. Draw a half circle as shown. Then cut on the dotted line.

3. Decorate the clown hat with any of the listed materials or any others may you have.

4. Hold the hat up to the child's head, and mark with a pencil. Then glue the 2 ends of paper together.

HATS: EXOTIC HEADGEAR - 1ST GRADE

MAKE AN EXOTIC HAT OR HEADPIECE

SUPPLIES: Pencil, scissors, glue, construction paper, fabric and yarn scraps, sequins, feathers, or any other materials to decorate the hats. A stapler, tape, crayons, markers, paints & brushes, & glue gun are helpful.

PROCEDURE:

1. The basic shape of the hat can be 6 x 18 piece of paper or tagboard that has been stapled into a cylinder, and then decorated.

2. Decorate the hat with any listed materials listed, or other ones available. Paper may be braided, rolled, curled, or folded and glued onto the basic shape.

3. Paints, markers, or crayons may be used for decoration.

4. Make each hat unique. Brims, hair, ears . . . may be added.

<p align="center">OR</p>

1. The basic shape of the hat can be a cone shape. See page 89 for directions.

2. Decorate as shown above.

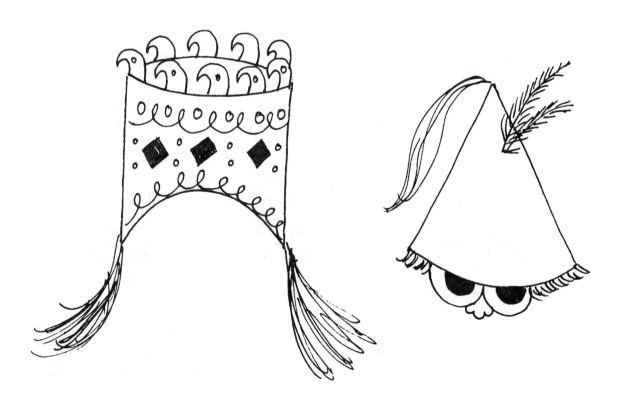

HATS: YANKEE DOODLE - 2ND GRADE

SUPPLIES: Pencil, scissors, glue crayons, markers, or paints and brushes, and a double sheet of newspaper for each child. You may also use wrapping or craft paper the same size (about 27 x 24).

PROCEDURE:

1. Put a double sheet of newspaper on the table with the fold at the top. If using kraft paper, fold the paper in half as shown.

2. Fold the paper in half, lengthwise as shown, and crease it on the fold. Open the paper back up so it is in the same position as step 1.

3. Lift the upper left-hand corner, and lay the folded edge of the paper along the crease. Do the same with the right side of the paper. Make a crease.

4. Run your finger along the 2 bottom pieces of paper, and fold the top piece up until it is even with the lower edge of the flaps. (See figure 4.) Turn the hat over and do the same thing again.

5. Finish the corners as shown, and glue them.

6. Hat can be worn 2 ways. Decorate the hat as desired. A feather can be made with a piece of paper 2 x 12.

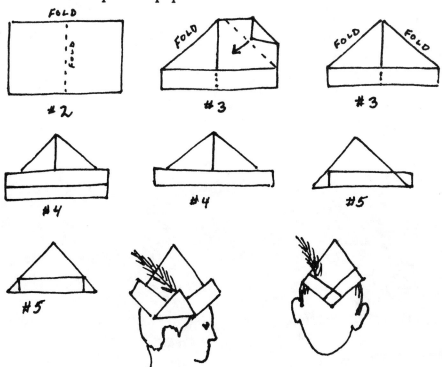

HATS: SUNVISORS - 3RD GRADE

SUPPLIES: Pencil, scissors, crayons or markers to decorate the visor, good masking tape, yarn or very thin elastic (about 8" per child), and tagboard.

PROCEDURE:

1. Using the supplied patterns, give each child a visor pattern and a top pattern. Cut these out of white, manilla, or colored tagboard.

2. Faces maybe drawn on the tagboard. On the top piece will be drawn the eyes. On the visor piece will be drawn nose, beaks, mouths, or any other details. Color as necessary.

3. Give each child 6 pieces of good masking tape, with each one being about 2-1/2 - 3" long.

4. Attach the top piece of tagboard to the visor with a piece of masking tape in the center first. (Match B with B.) Be sure to put tape on the BACK of visor.

5. Attach the two pieces of the visor together at both ends next (A's and C's). Put tape on BACK of visor only. Then finish attaching the 2 pieces with the rest of the masking tape.

6. Tape yarn to both ends of the visor sides, or use very thin elastic, to fit the visor to the head.

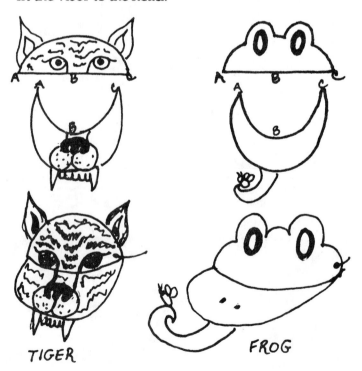

TIGER FROG

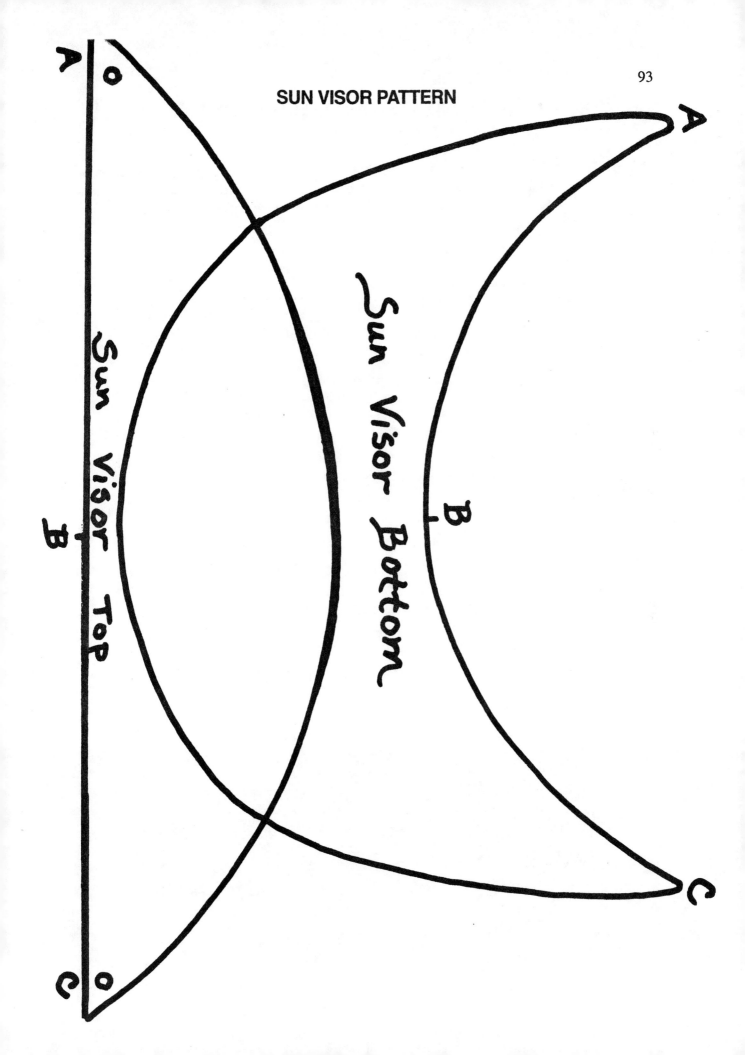

SUN VISOR PATTERN

93

MUSICAL INSTRUMENTS: RATTLES - KINDERGARTEN

SUPPLIES: Pencil, crayons or markers, crepe paper (optional), glue, 2 paper plates per child, 1 popsicle stick or tongue depressor per child, scissors, and staplers. Seeds, pebbles, or any other small objects to make noise inside the rattles are needed.

PROCEDURE:

1. Draw and color designs or pictures on the back side of each paper plate. (Each child needs 2 plates.)

2. Paper streamers may be glued to the front side of 1 paper plate as shown:

3. A popsicle stick or tongue depressor may be glued to the front side of the same paper plate (for use as a handle).

4. Put glue on the uncolored side of one paper plate. Staple the 2 plates together with the drawings both showing. Staple all the way around the plates, but leave an opening about 2" wide.

5. Put small noisy objects, such as pebbles, beans or seeds into the 2" opening. Staple the opening shut so the objects don't fall out of the rattle.

6. HAVE FUN SHAKING THE RATTLES YOU'VE MADE!

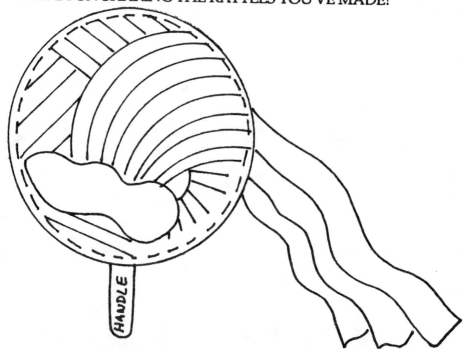

MUSICAL INSTRUMENTS: TAMBOURINE - 1ST GRADE

SUPPLIES: 1 metal pie tin for each child, a hole punch, scissors, pipe cleaners or yarn, 4 jingle bells per child, and permanent markers to decorate the tin.

PROCEDURE:

1. Punch 4 holes along the rim of each pie tin.

2. String 1 jingle bell on a piece of yarn or pipe clearner, and tie or twist them to each hole.

3. The pie plate may be decorated with permanent markers.

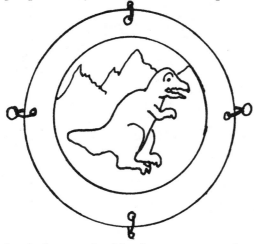

(Bottle caps with a hole punched in the center may be substituted for jingle bells. Be sure to put 2-3 bottle caps at each hole.)

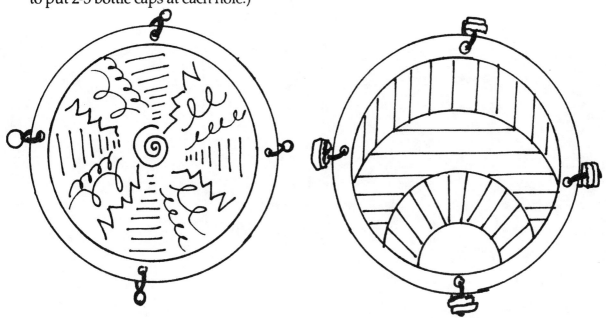

MUSICAL INSTRUMENTS: CASTANETS - 2ND GRADE

SUPPLIES: 1 wooden paint stir stick per child or 2 tongue depressors per child, pencil, glue, felt scraps, scissors, markers to decorate if wanted, and a sharp utility knife or paper cutter for the teacher's use.

PROCEDURE:

1. Give each child 1 wooden paint stir stick or 2 tongue depressors.

2. If using stir sticks: cut 2 pieces off the end with a sharp utility knife or paper cutter. Each piece should be 2-1/2" long.

3. If using tongue depressor: cut one in half.

4. Cut 2 pieces of felt per child which are each 1" x 2". These pieces of felt will be glued as shown:

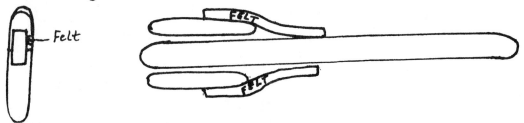

5. Finish decorating the castanets with markers or fabric on the outsides only.

6. Let the glue dry, and then have fun making music!

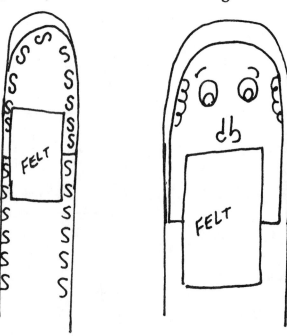

MUSICAL INSTRUMENTS: DRUM - 3RD GRADE

SUPPLIES: Vegetable or soup cans (with both ends removed), pencil, pieces of a rubber inner tube or leather, masking tape, glue, scissors, yarn or heavy twine, a hole punch, and markers or paint to decorate the drum. Fabric scraps or paper scraps may also be used.

PROCEDURE:

1. Each child needs a clean can with both ends removed.

2. Cut 2 circles 3/4" larger than the can for each child. Use pieces of a rubber inner tube or leather for circles. (Trace the can and cut each circle a little larger than the can, about 3/4" larger.)

3. Punch 4 holes in the exact same places on each circle:

4. If you want to decorate the entire can with paper or fabric, cut a large piece 3-1/2" x 11". Put glue all over the outside of the can and spread it around with your finger. Apply paper or fabric to fit.

5. Cut 4 pieces of yarn or heavy twine for each child, which are 7" long.

6. Place a piece of inner tube on the top and bottom of each can. Tie the yarn as shown:

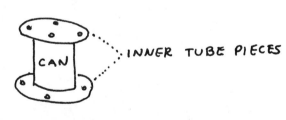

7. Finish decorating the drum with any of the above materials.

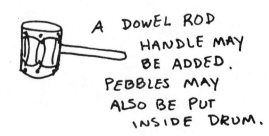

PAPER SCULPTURE: SHADOWBOX - KINDERGARTEN

SUPPLIES: Pencil, scissors, glue, shoebox, paper and fabric scraps, tiny boxes, spools, markers or crayons, scotch tape, and any other materials. Popsicle sticks, twigs, yarn, or clay may be used too.

PROCEDURE:

1. Turn the shoe box on its side so the opening faces you. Decide what type of shadowbox to make: pilgrims, log cabins, dinosaurs, the wild west, the desert, outer space, underwater....

2. If windows need to be added, draw with a pencil on the sides of the box. Then carefully cut them out. Fabric may be added for curtains.

3. Popsicle sticks may be glued to the outside of the box for use as a log cabin. Aluminum foil may be glued to the outside and inside of the box for an outer space or underwater scene. Paint or color with markers if needed.

4. Sticks, sand, dried weeds, shells, or sawdust may be glued to the floor of the box.

5. Furniture may be made from spools, small spools, or paper scraps, rolled or folded.

6. People, animals, cacti, trees, fish,or seaweed should be drawn on paper, colored, and have a tab on the bottom which can be folded and glued or taped. Objects may be hung from the top with string too. HAVE FUN MAKING THEM UNIQUE!

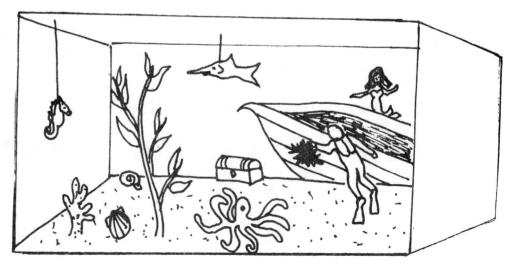

PAPER SCULPTURE: BUTTERFLIES - 1ST GRADE

SUPPLIES: Pencil, scissors, 2 garbage twist ties per child, ruler, and colored magazine pictures or wrapping paper.

PROCEDURE:

1. Cut a 7" square of a colored magazine picture or a piece of wrapping paper. It doesn't matter what the picture on the paper is. The butterfly will be prettiest with brightly colored paper. THIS PIECE WILL BE THE BUTTERFLY'S TOP WING.

2. Cut another piece of colored paper for the BOTTOM WING. There is a pattern below for the exact shape.

3. Fold each wing separately, back and forth, like a paper fan. (The smaller the sections are folded, the better the butterfly will look.) Paper clip each piece when finished to hold its shape.

4. Remove paper clips and put the butterfly together. Secure with a twist tie. Another twist tie can be looped through the first one and curled like antennas.

Wing

START FOLDING HERE.

Top

FOLD, CUT OUT, AND THEN OPEN IT UP

Bottom Butterfly Wing

7" SQUARE

Top Butterfly Wing

PAPER SCULPTURE: BOXES - 2ND GRADE

SUPPLIES: Pencil, scissors, glue, ruler, white or colored paper, and crayons, markers, or paints & brushes to decorate box.

PROCEDURE:

1. Use a 3" square for a pattern to draw the shape below, or draw the entire pattern with all 6 squares for each child.

2. Cut out the entire shape, but be careful - DON'T CUT OFF THE FLAPS!

3. Fold towards you along all lines. You may want to use a ruler to get sharper creases. Fold in flaps too.

4. Glue the 4 side flaps, and put them inside to form the 4 corners of the box. Decorate as desired.

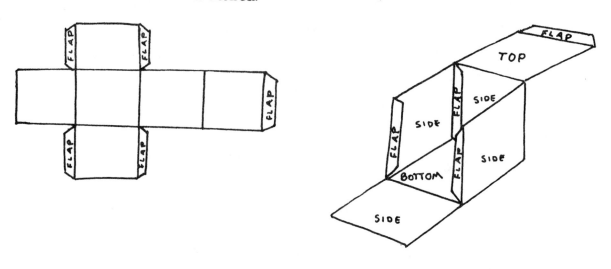

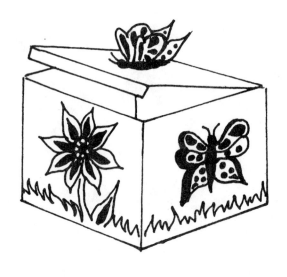

PAPER SCULPTURE: HOUSES - 3RD GRADE

SUPPLIES: Pencil, scissors, glue, paper, and crayons, markers, or colored pencils to decorate houses, & ruler.

PROCEDURE:

1. Take a piece of 9 x 12 paper, and fold in half lengthwise.

2. Open it up and fold both outside edges to the middle.

3. Fold the top and bottom ends the same width as sides. Use a ruler if necessary.

4. Make 3 cuts at each end of the paper. STOP AT THE FOLD. DO NOT CUT PAST THE FOLD.

5. Turn it over, and fold it to make a house shape. Glue both ends to hold its shape. You may want to use paper clips to hold the shape before gluing it.

6. Cut doors, windows, and chimneys, and decorate as desired. You can make an entire village this way.

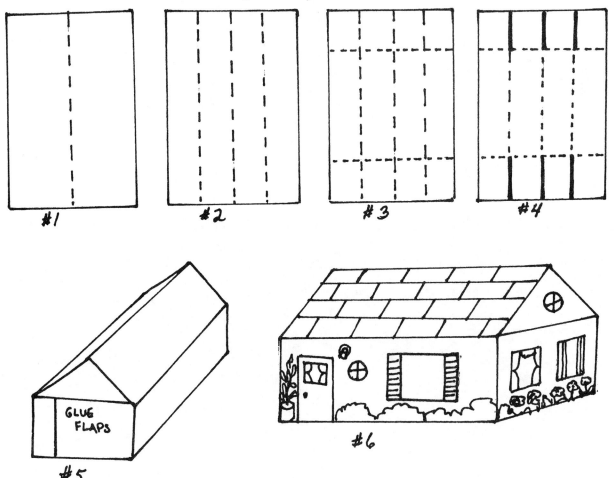

#1 #2 #3 #4

GLUE FLAPS

#5

#6

1. **LEAF PRINTS:** See printmaking unit. Paint leaf and print it.

2. **LEAF RUBBINGS:** See crayon unit. Put leaf under paper & rub crayon over the surface for a textured copy of the leaf.

3. **LEAF STENCILS:** See printmaking unit. Cut out leaf shapes and use them as stencils, or use the actual leaf as a stencil.

4. **PAINTING WITH LEAVES:** Use leaves like a paintbrush. Apply tempera paint to the leaf, and paint with it.

5. **LEAF COLLAGES:** Glue leaves onto a piece of cardboard for a collage, or place leaves between 2 pieces of wax paer and iron till it is sealed. Leaves may be combined with other nature objects for collages too.

6. **LEAF MOBILES:** Seal leaves in wax paper, cut apart and hang as a mobile. Or you can also draw and color leaves on white or colored paper, and hang them as a mobile. Be sure to color both sides of the leaves. Leaves that have been preserved with glycerine make great mobiles.

7. **LEAF SKETCHING AND IDENTIFYING:** Look at different types of leaves. Trace or draw them free hand. Color and label them. Try painting leaves individually, or on various trees.

8. **PRESERVE LEAVES WITH GLYCERINE:** Spread out leaves on newspapers. Cut off the ends of each stem. Mix in 3: 1 ratio: warm water with glycerine, and put in a jar. You can purchase glycerine at the drug store. Leave the leaves in the jar for 1 week. Remove them to use as desired.

WEED ART: SUGGESTED ACTIVITIES

1. **WEED PRINTS:** See printmaking unit. Paint weed & print it.

2. **CLAY PLAQUES WITH WEEDS:** Make a clay (or plaster) slab & press weeds or flowers into it while soft. Let dry, and hang up.

3. **WEED WALL HANGINGS:** Glue weeds, seeds, pods, leaves . . . onto a piece of felt or burlap for a wall hanging.

4. **WEED PAINTINGS:** Thin down tempera paint and use weeds for brushes.

5. **WEEDS IN A VASE:** Collect various weeds, cattails . . . & place in vase.

NATURE CRAFTS: 1ST GRADE
STONE ART: SUGGESTED ACTIVITIES

1. **STONE SCULPTURES:** Collect stones and glue them together (with a hot glue gun) to make animals or people. Paint them with acrylic or tempera paint. If using tempera paint, spray varnish when dry.

2. **STONE PAPER WEIGHT:** Collect large stones to be used as paperweights. They can be decorated with permanent markers or paints. Draw or paint a "surprise" on the bottom of the paper weight.

3. **STONE PRINTS:** See printmaking unit. Paint stones & print them.

4. **STONE SKETCHING AND IDENTIFYING:** Look for different types of rocks. Try to find fossils, quartz, sandstone . . . Draw pictures of the rocks (or use the actual rocks) and label them.

5. **STONE MOSAICS:** Glues stones, seeds, pods, gravel, sand, twigs, bark, weeds, flowers . . . onto stiff cardboard for mosaics.

STONE ANIMAL **PAPER WEIGHT** **STONE PRINTS** **STONE**

SKETCH **STONE MOSAIC**

NATURE CRAFTS: 2ND GRADE
SHELL ART: SUGGESTED ACTIVITIES

1. **SHELL MAGNETS:** Glue together shells with pipecleaners or fabric scraps to make animals, flowers, insects . . .

2. **SHELL JEWELRY:** Holes can be drilled into the shells for stringing necklaces or bracelets. Using jewelry findings and a glue gun, pins, earrings, or rings can be made too. Seeds, nut shells, or pods may be used with the shells for a variety of jewelry.

3. **SHELL WINDCHIMES:** Shells may be drilled and strung with fishing line. They may be hung from assorted twigs. Make sure that the shells will touch if moved, to make beautiful windchime sounds.

4. **SHELL FLOWERS:** Shells can be arranged into beautiful flower shapes, and glued onto a stiff piece of cardboard, felt, or burlap. They can also be arranged on a wet slab of plaster, and left to dry there. Flowers can be made 3D to be glued onto sticks or pipecleaners, and placed into some type of vase.

5. **SHELL & FOUND OBJECT MOSAICS:** Shells, seeds, pods, rocks, or other found objects can be glued onto a stiff cardboard for use a picture mosaic.

SHELL JEWELRY

SHELL MOSAIC

SHELL FLOWER

SHELL MAGNET

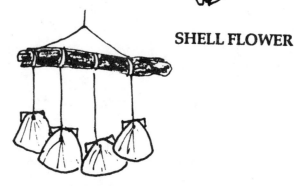

SHELL WINDCHIMES

NATURE CRAFTS: 3RD GRADE
TWIG ART: SUGGESTED ACTIVITIES

1. **GOD'S EYES:** Crisscross 2 twigs (any size), wrap with yarn, and tie a tassle on the bottom. To make a yarn tassle, wrap yarn several times around a cardboard, tie at the top, and remove. Wrap yarn around the center of the tassels, and clip the bottom loop as shown.

2. **TWIG MOBILES WITH FOUND OBJECTS:** Use twigs, string, and found objects to make beautiful mobiles.

3. **TWIG WEAVING:** Use twigs as a frame for weaving. Review weaving unit. Leave twigs in the finished weaving, or remove them.

4. **TOTEM POLES:** Sketch the design for the totem pole on a piece of paper. Then draw it on the wood. Carve where desired. Paint with tempera or acrylic paints. If using tempera paints, spray with varnish when finished. A wooden base may be nailed or glued onto the totem pole.

SAND ART: SUGGESTED ACTIVITIES

1. **SANDCASTING:** Use spoons to dig a hole in the sand (at the beach or in a box). Place any desired objects, facing down, in the bottom of the hole. Mix plaster as directed, and pour into the hole. Let it harden, and remove. It will have a nice texture with some sand clinging to the surface. THIS PROCESS ALSO WORKS WELL WITH ANIMAL TRACKS. Simply pour the liquid plaster into the tracks, let dry, an carefully remove the plaster from the tracks.

2. **SAND CANDLES:** Using spoons, dig a hole in sand for the shape of the candle. Place any desired objects on the sides and bottom of the hole. Be sure that the objects face outward, not inward. Anchor 1 string to the bottom of the hole, and attach the other end to a long stick which stretches across the candle opening. Melt paraffin wax and pour it into the sand hole. Let cool, and remove the candle carefully.

3. **SAND PAINTING:** Add dry tempera paint to sand until desired color is obtained. Stir well, and continue mixing all desired colors of sand. Spoon the mixture into jars or sprinkle onto cardboard (for a picture). Seal jars of sand with melted wax.

CLAY
DEFINITIONS

WEDGE: This is the process of removing air pockets form the clay. The clay is thrown down on a table, and gently turned and kneaded.

PINCHPOT: This type of small container is made from a tennis ball sized piece of clay. A hole is made in the center of the ball with one's thumb. The thumb is on the inside, and the other fingers are on the outside of the bowl shape. The clay is gently rotated and squeezed into the desired bowl shape.

COIL METHOD: This method uses long, ropelike pieces of clay. The clay is wedged, and then made into long coils. The coils may be placed on a 1/2" thick slab of clay or a small pinchpot. The coils are then added, one at a time. Use a drop of water between rows of coils to make the clay stick together better. The coils should be smoothed out on the inside or backside of the clay. The front or outside of the shape may be smoothed out or left with the coils showing.

SLAB METHOD: This method uses clay which has been rolled or flattened (with a rolling pin or with a hand), with about a 1/2" thickness. The slabs may be cut into geometric shapes to make: boxes, windchimes, planters. The slabs can also be cut into rectangular or triangular shapes, and rolled into a cylinder or cone shape. They can be used for: mugs, planters, or other containers.

BISQUE FIRE: This is the initial clay firing in a kiln or other type of heat source. The clay pieces are usually NOT GLAZED for this step. Occasionally, a clay pot will explode and come apart during the bisque firing. This is due to trapped air pockets or poor construction methods. If the pieces were glazed, and they exploded, everything near that piece would be ruined.

GLAZE: This is a type of surface decoration and protection for clay pieces. It is similar to paint, when fired, but it also makes the clay piece waterproof. If using the clay pieces for food or drink, make sure that they don't contain lead. I NEVER USE ANY LEAD GLAZES WITH CHILDREN AT ALL. Stir the glaze well, and apply 2-3 coats.

DRYFOOT: This means to remove any glaze or foreign substance from the bottom of a clay piece. This is done by simply using a wet paper towel or sponge to clean the bottom of the clay piece.

CLAY: PINCHPOT - KINDERGARTEN

SUPPLIES: Newspaper, 1 lb. clay per child, water bowls at each table, and pencils, popsicle sticks, or other decorative carving tools.

PROCEDURE: Review the previous page.

1. Give each child a 1 lb. piece of clay. This is about the size of a baseball or tennis ball.

2. Put newspapers and bowls of water on work tables.

3. Gently wedge the clay on the newspapers, to remove any air bubbles.

4. Roll the clay into a smooth ball. Add a drop or two of water to your hands if the clay starts to form cracks.

5. Hold the ball in one hand, and gently make a hole in the center with the opposite thumb.

6. Gently rotate the ball, and press out the inner hollow so the shape is gradually deepened. This is done by putting your thumb inside the clay shape, and your other fingers on the outside of the clay. Gently press and turn the clay. It will gradually get larger, in a bowl shape.

7. When you are satisfied with the shape of the pinchpot, decorate with a pencil, popsicle stick, or other object. Experiment with different objects to decorate the outside of the pinchpot. Use a pencil to put names or initials on the bottom of the pinchpot.

7. Let dry completely.

8. Bisque fire the clay pots.

9. Paint on 2 coats of glaze. Don't put any glaze on the bottom of the pinchpot. If some accidentally gets on the bottom, simply sponge it off with a damp sponge.

10. Glaze fire, and enjoy!

CLAY PINCHPOTS MAY BE USED FOR: TINKET BOXES, JEWELRY, SCOURING PAD HOLDERS, CANDLE HOLDERS . . .

CLAY: TRIVETS - 1ST GRADE

SUPPLIES: Newspaper, 1 lb. clay per child, water bowls at work tables, and pencils, popsicle sticks, or other decorative tools. 8" square wood or cardboard/child.

PROCEDURE: Review page 106.

1. Give each child a 1 lb. piece of clay. This is about the size of a tennis or baseball.

2. Put newspapers and bowls of water on work tables.

3. Gently wedge the clay on newspaper, to remove any air bubbles.

4. Give each child an 8" square piece of wood or stiff cardboard. This will be used as a base. Students will build their trivets on the base, and leave them there until dry.

5. Cover the board or cardboard with newspapers.

6. We will be making the trivet upside down. Pinch off small pieces of clay, and roll them into balls. Pinch off larger pieces of clay, and roll them into coils. Add a drop of water between clay pieces (stick better).

7. Arrange the coils and balls as desired on the newspapers. They must touch each other. The coils can be rolled or curved as shown.

8. When the entire square is full of clay shapes, gently smooth together with a popsicle stick or finger. If the clay cracks, add a drop of water, and smooth. Remember, this is the back of the clay trivet. Gently lift up, and peek at the front, to see if you like it or not.

9. Let dry.

10. Bisque fire.

11. Paint 2 coats of glaze on the front only. Be sure to dryfoot the trivet.

smooth out the back side of the clay trivet.

CLAY: SLAB WALL HANGING - 2ND GRADE

SUPPLIES: Newspapers, 1 lb. clay per child, water bowls at work tables, pencils, popsicle sticks, and rolling pins or large dowel rods (to be used like rolling pins). Plastic doilies are useful too.

PROCEDURE: Review page 106.

1. Give each child a 1 lb. piece of clay. This is about the size of a baseball or tennis ball.

2. Put newspapers and bowls of water on work tables.

3. Gently wedge the clay on newspapers, to remove any air bubbles.

4. Flatten out the clay with your hand, a rolling pin, or a large dowel rod. The clay should be about 1/2" thick.

5. Cut out a shape for the back piece & pocket. Use a kitchen knife, pencil, or popsicle stick.

6. The surface of the two clay pieces may be textured and decorated as desired. A plastic doily may be placed on the clay surface, and gently rolled over with a rolling pin. This will put the designs on the clay. Or other designs may be pressed and drawn directly on the clay. Put name or initials on the clay.

7. Put a few drops of water on the edges of the pocket sides and bottom, and press into place. Stuff the pocket with small pieces of kleenex or newspaper (so that the pocket will hold its shape).

8. Let dry.

9. Bisque fire.

10. Glaze 2 coasts, and dryfoot, or paint it.

pocket

CLAY: WINDCHIMES - 3RD GRADE

SUPPLIES: Newspapers, 1 lb. clay per child, water bowls at each table, and pencils, nails, popsicle sticks, or other decorative carving tool. A cardboard or wood scrap may be used to place the clay pieces for drying. Fishing line is needed to string the windchimes, and a few pairs of scissors are needed also.

PROCEDURE: Review pages 106-109.

1. Give each child a 1 lb. piece of clay. This is about the size of a baseball or tennis ball.

2. Put newspapers and bowls of water at work tables.

3. Give each child a piece of wood or cardboard for keeping their clay pieces together. Styrofoam meat trays work fine too. Cover the surface with a newspaper.

4. Review pinchpot, coil, and slab techniques.

5. Have sudents sketch windchimes as needed. Cookie cutters, kitchen knives, nails, or pencils may be used to cut out the clay shapes. Decorate as desired.

7. Poke a hole in the top of each windchime piece. Use a nail or a pencil. Put initials on each piece of clay.

8. The top part of the windchimes may be made from clay, a dowel rod, or a stick.

9. Dry, and bisque fire.

10. Glaze 2 coats and dryfoot, or use acrylic paint, and paint both sides.

11. String the windchmes, and enjoy!

PASTEL TECHNIQUES

SUPPLIES: White, manilla, or colored paper, colored pastels (chalks), pencil, eraser, and kleenex.

PROCEDURE:

1. Lightly sketch a picture with a pencil. It can be a scene, still life, or portrait.

2. Always start coloring with pastels at the top of a picture. That way, there is less chance that it will smear. Pastels look better when 2 or more colors are put on top of one another, and blended with a tiny piece of keenex. Don't blow the chalk dust. It may go in someone's eye. Shake the dust off the paper gently instead.

3. Techniques used in shading the sky: In order to give depth to the sky, try to make the top part of the sky darker, and gradually lighten it up as it comes down to the horizion line. This can be done by adding: white over the blue pastel, red to the dark blue (for a violet color), or by putting yellow on the entire sky, and gradually adding orange and red as the sky goes up toward the top of the paper. Blend slightly with kleenex if desired. Pastels can be erased, if necessary.

4. Mountains or hills: They look more realistic if one side is shaded light, and the other side is shaded darker. For example: shade an entire mountain light blue, then add dark blue to the dark side, and white to the light side. Blend lightly. Shade hills green, with yellow on the light side, and a little brown on the dark side. Blend if needed.

5. As objects come closer to the front of the paper, THEY LOOK BRIGHTER AND MORE DEFINITE. They don't need to be smeared or blended. (Example: trees, buildings, grasses, cat tails, waves, splashes, animals)

6. Techniques used in shading water for lakes and streams: Water will normally reflect the colors around it. So, instead of just plain blue water, add other colors which might be reflected into the water. White can be added (don't smear it) to show waves or water movements. Make the water more colorful in the front of the picture. Be careful if adding orange to blue pastel. Complementary colors will turn an ugly shade of brown if blended a lot.

7. Techniques used in shading animals: Lightly color the animal with pastel. Add dark shadows if necessary and blend. Add feathers, hair, or fur if desired. Do not blend them.

PASTEL TECHNIQUES - CONTINUED

8. Techniques used in a pastel portrait: Shade the entire face with a flesh color. Add a little brown, pink or red to the sides and darker areas of the face. Blend well. Draw eyes, mouth, nose, and hair, but do not smear them. White highlights may be added to the eyes, nose, mouth, and hair if necessary.

9. Techniques used if making a pastel still life: Color the objects a basic color first, then add white to the light side and a darker color to the dark side. Blend slightly. Add highlight and don't blend the color and blend the background. Remember to add shadows if possible.

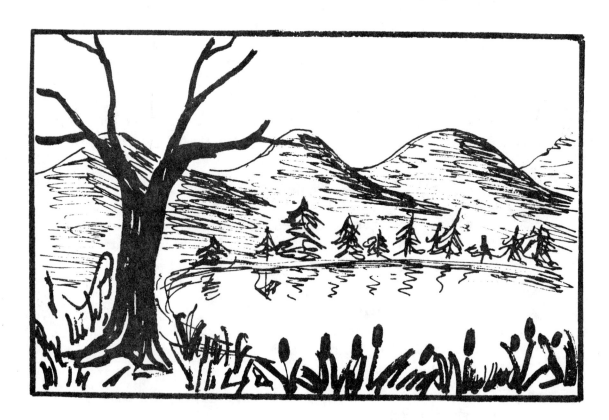

PASTEL: K-3 PROJECTS

REVIEW THE TWO PREVIOUS PAGES FOR SUPPLIES & TECHNIQUES

KINDERGARTEN

Make a wonderful pastel face.

1ST GRADE

Make a pastel bird or fuzzy animal.

2ND GRADE

Make a beautiful pastel scene.

3RD GRADE

Make an interesting pastel still life or vase of flowers.

COLUMBUS DAY: SHIPS - KINDERGARTEN

SUPPLIES: Pencil, scissors, glue, white & colored paper, rulers, pipecleaners, crayons, markers, or tempera paints & brushes.

PROCEDURE:

1. Discuss Columbus Day and the 3 ships that sailed: the Nina, the Pinta, and the Santa Maria.

2. Draw the 3 ships on colored construction paper & cut out. It will be a more interesting composition if you vary the sizes of the 3 ships. The largest should be no larger than 10" x 6". Draw only the wooden parts on brown, gray, or black paper. See examples below.

3. Cut sails to fit the boats out of white paper.

4. Glue the smallest (background) boat on light blue 12 x 18 paper. Draw, cut out and glue on a row of dark blue waves that partially cover the bottom of the boat. Glue the medium sized boat on next. Add a row of waves partially covering the bottom of the boat. Next add the largest boat and waves in front of it.

5. Glue pipecleaners or paper strips on for the boat masts.

6. Glue on white masts. They may be partially curled around a pencil first, and then glued on in a few spots only.

7. The boats, sails, or water may be decorated with crayons, markers, or paints.

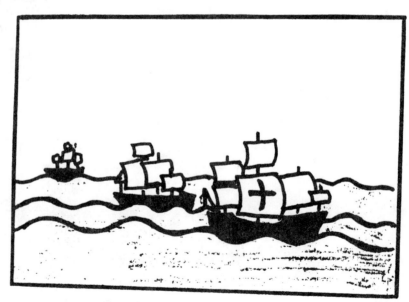

COLUMBUS DAY: SHIPS IN A BOTTLE - 1ST GRADE

SUPPLIES: White tagboard, tempera paints & brushes, pencil, scissors, scotch or masking tape, and clear plastic wrap.

PROCEDURE:

1. Review Columbus Day and the types of ships that sailed.

2. Lightly draw the shape of a bottle on white tagboard. Students may want to make a bottle pattern from scrap paper. Fold it in half, and cut it out. The pattern may then be traced on the tagboard.

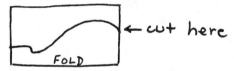

3. Draw 1 of Columbus' ships inside the bottle. Paint it with tempera paints. The sky and water should be painted too.

4. When dry, cut out the bottle.

5. Spread a piece of clear plastic wrap over the front of the picture, and trim it a little larger than the tagboard. Tape the plastic to the back of the bottle. WHEN FINISHED IT SHOULD LOOK LIKE A SHIP IN A BOTTLE.

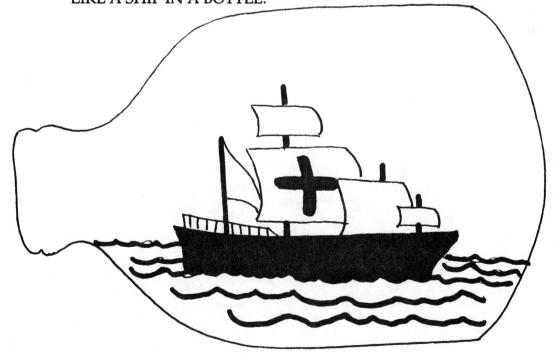

COLUMBUS DAY: 3D SHIP - 2ND GRADE

SUPPLIES: Pencil, scissors, glue (a glue gun is great if used by an adult), hole punch, woodgrain contact paper. Straws, popsicle sticks, or pipeclearners for masts. Markers or crayons to decorate the sails and white paper for sails. Each child will also need a clean liquid dishwashing bottle. Modeling clay is optional.

PROCEDURE:

1. The teacher or another adult should cut the bottom off the dishwashing bottles so they are about 3" tall. This will be used for the boat. Use sharp scissors or a utility knife.

2. Give each child 2 pieces of woodgrain contact paper. Each should be about 3-1/2" x 8" (with the woodgrain horizontal). Let them stick 1 piece to each side of the boat.

3. Students may than cut the top of the ship more decoratively as shown below, or punch out portholes with a hole punch.

4. Sails may be drawn and decorated on white paper.

5. Straws, popsicle sticks, or pipeclearnrs, or even a piece of the bottle may be used for masts. Use modeling clay, or an adult can use a glue gun to attach the mast to the boat. Sails may then be glued to the mast(s).

6. Any extra details may be added: sailors, waves . . .

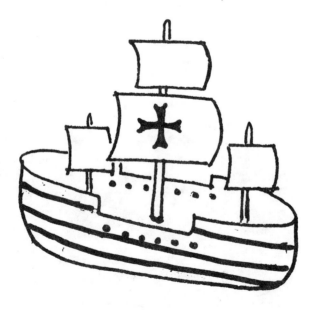

COLUMBUS DAY: SHIP MOBILES - 3RD GRADE

SUPPLIES: Pencil, ruler, scissors, glue, string, white paper for sails, brown paper for masts, twigs or a clothes hanger to hang the mobiles, and walnut shells or brown paper for boats, and crayons or markers to draw with.

PROCEDURE:

1. Draw masts on brown paper as shown, about 1" x 2". Cut out and set aside.

2. Cut white sails to fit the masts, and glue them on. They may be decorated with crayons or markers. Some sails may be folded or curled before they're glued. See examples below.

3. The body of the ship can be made from empty half walnut shells, or brown paper folded in half and glued as shown.

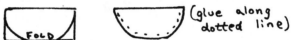

4. Finish each boat and attach a string or piece of thread to the top of the center sail.
 Boats may be hung from twigs, dowel rods, coat hangers, or individually.

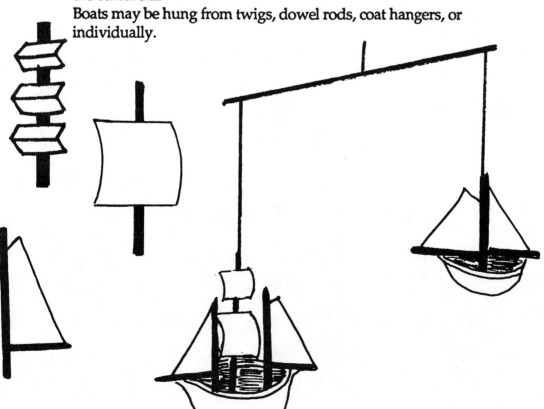

HALLOWEEN: KINDERGARTEN

HALLOWEEN MOBILES

SUPPLIES: Pencil, scissors, glue, black and gray paper, a 3" x 12" strip of tagboard for each child, a hole punch, colored chalks, crayons, markers, or paints & brushes, string, and a stapler.

PROCEDURE: REVIEW MASKMAKING UNIT FOR OTHER IDEAS.

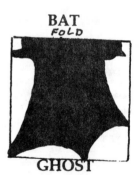

1. Give each child a tagboard to decorate. This will be the mobile hanger.

2. Curl each tagboard into a cylinder, and staple together.

3. Punch 4 holes in the cylinder - to hang the objects for the mobile. Space them evenly.

4. Hang a string from each hole, and hang a Halloween object at the end of each string.

5. Make: cats, spiders, bats, pumpkins, witches . . . See directions below.

6. Make ghosts: twist the center of a square piece of toilet paper. This will be the ghost's head. Wrap the end of a string around the neck, and hang from the mobile.

7. Attach a piece of string to the top of the tagboard, and hang it up in the classroom.

CAT

FOLD

SPIDER

FOLD

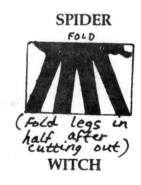

(Fold legs in half after cutting out)

BAT

FOLD

PUMPKIN

FOLD

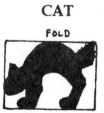

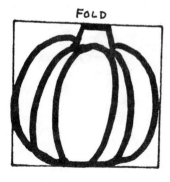

WITCH

GHOST

HALLOWEEN: 1ST GRADE

PAPER PLATE SPIDERS

SUPPLIES: Pencil, scissors, glue, paper plates (small or large), black construction paper (cut into 1/2" or 1" strips, 12" long), yarn for hanging up the spider, and scrap paper for the spider's eyes, black paint & brushes.

PROCEDURE: REVIEW MASKMAKING UNIT FOR OTHER IDEAS.

1. Give each student a paper plate for the spider body. Paint both sides of the paper plate black.

2. Make eyes on scrap paper, and glue them onto the dry spider body. See example. Make sure that there is a small tab on the eyes which can be glued onto the paper plate.

3. Take 2 black paper strips and place them at right angles, as shown. Glue the 2 ends together.

4. Fold the 2 paper strips back and forth, and glue the other 2 ends together. Do this for each spider leg (8 legs).

5. Attach the legs to the plate with glue or staples.

6. Poke a hole in the center of the plate, and hang up the spider.

HALLOWEEN: 2ND GRADE

HALLOWEEN POP-UP CARDS

SUPPLIES: Pencil, scissors, glue, colored chalks, assorted color papers, crayons, and markers.

GHOST POP-UP CARD

PROCEDURE: REVIEW MASKMAKING UNIT FOR OTHER IDEAS

1. Use a piece of paper 4 x 8 for the card. Fold as shown: in half, a triangle at the top, and then opened up and folded in half the other way.

2. Close the card, and pull out the triangular part. Draw and cut out a shape on the triangular piece as shown. Decorate with chalk, crayons, or markers.

WITCH ON A BROOM CARD

SUPPLIES: The same as above.

PROCEDURE:

1. Draw the backside of a witch in the center of a piece of paper. Color with any desired materials.

2. Accordion fold a piece of paper (for the broom) which is about 2" x 12".

3. Glue the folded broom inside the card, as shown, and keep the card closed until the glue is dry.

4. Decorate the front of the card as desired.

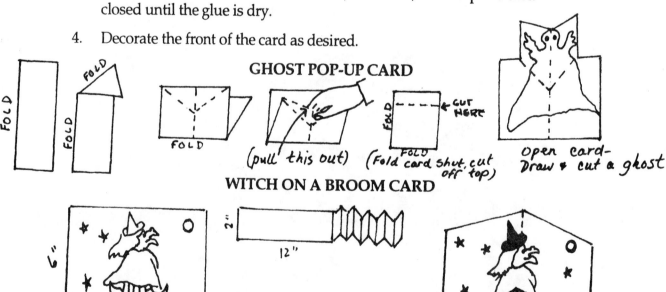

GHOST POP-UP CARD

WITCH ON A BROOM CARD

HALLOWEEN: 3RD GRADE

HAUNTED HOUSE WITH PEEP HOLE

SUPPLIES: Pencil, scissors, glue, assorted papers, markers, crayons, string, paints & brushes, and a shoe box for each child.

PROCEDURE: REVIEW MASKMAKING UNIT FOR OTHER IDEAS

1. Cut an opening on one narrow end of the box.

2. Cover the opening with a piece of tissue paper, glued to the inside of the box.

3. Use a dark piece of construction paper, to glue over the tissue paper, with fancy or spooky windows. See example.

4. Paint the inside of the box as desired.

5. Make a small hole in the opposite end of the box. Draw or paint a scary picture or face there. (The hole will be used for looking into the box.)

6. Make figures to hang in the box (which can be hung from a string and hole in the lid of the box). Attach a paper clip to the outside end of the string, and you can move the figures when someone is looking into the box.

7. Make other figures with tabs on the sides or bottoms. Glue the tabs on the box sides and walls. Have all figures face forward, toward the small hole in the front of the box, with the tabs facing the back of the box.

8. Cut slots in the sides of the box, and slide in a piece of tagboard with a figure attached to the center. See example.

9. Finish as desired. Let friends "PEEP" into the haunted house.

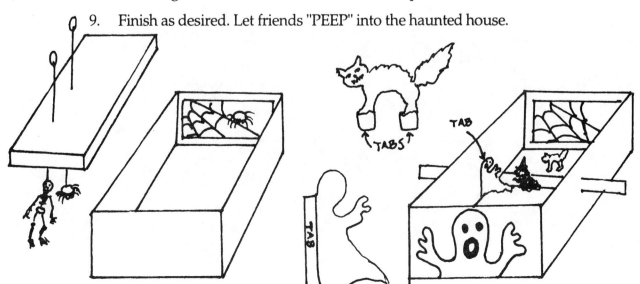

THANKSGIVING: KINDERGARTEN

INDIAN HEADDRESSES

SUPPLIES: 3 x 24 strips of tagboard, paints & brushes, markers, crayons, pencil, scissors, glue, colored paper scraps, stapler, and feathers. If no feathers are available, they can be made from a piece of 3 x 12 colored paper or tagboard. Other notions, such as: sequins, lace, buttons, colored beadsmay be desired.

PROCEDURE:

1. Give each child a tagboard strip, and staple it together for a good fit.

2. Decorate the headdress with any of the listed materials.

A VARIATION OF THIS PROJECT WOULD BE HEADDRESS TABLE FAVORS.

BALLOON TURKEYS

SUPPLIES: 1 balloon per child, colored paper, a glue gun (to be used by an adult), pencil, scissors, white paper, and tempera paints & brushes or markers.

PROCEDURE:

1. Give each child a balloon to blow up. This will be the turkey's body.

2. Draw and cut out beautiful tail feathers and wings to be glued on the body. Paints or markers may be used too.

3. Make a head to be glued on the body.

4. With a glue gun, glue all body parts on the balloons. Then glue a flat piece of paper or tagboard (about 3 x 3) to the bottom of the balloon.

5. Finish decorating the turkey as desired.

A VARIATION OF THIS PROJECT WOULD BE TURKEY FAVORS USING VERY TINY BALLOONS.

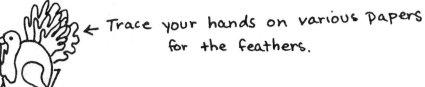

← Trace your hands on various papers for the feathers.

THANKSGIVING: CORNHUSK PUPPETS - 1ST GRADE

SUPPLIES: Glue, bowls, brushes, pencil, colored paper, fabric scraps, yarn, cornhusks (2 per child) dowel rods or sticks, and scissors.

PROCEDURE:

1. Give each child 2 cornhusks. Fold them in half together, and put a stick or dowel rod in the center of the husks as shown. Tie with a piece of yarn. The husk above the yarn will be the puppet head.

2. Make a mixture of watered down glue and water to be brushed on each puppet's outside cornhusk. Brush mixture on each puppet, and let dry.

3. Draw and cut out features for the puppet faces - Pilgrims or Indians. Glue them on the head of the puppet.

4. Make fabric or paper clothing, hats, headdresses, or any other details, and glue them onto the puppet. Yarn may be tied as shown, and glued on the puppet for hair. If making an Indian, the yarn may be braided too.

5. Finish decorating the puppets as desired.

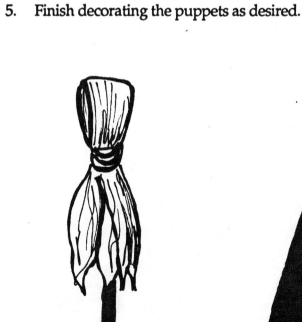

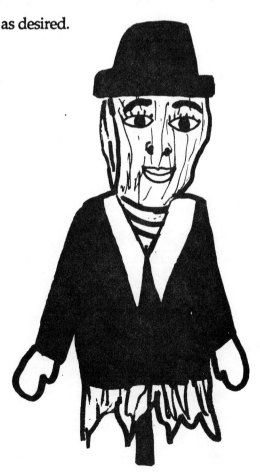

THANKSGIVING: PAPER BAG PILGRIMS & INDIANS - 2ND GRADE

SUPPLIES: Pencil, scissors, glue, tempera paints & brushes, newspapers, construction paper, and yarn & fabric scraps. Each child will also need a paper lunch bag.

PROCEDURE:

1. Stuff a paper bag with small pieces of newspapers.

2. Fold the top over and glue or staple it shut.

3. The body of the Pilgrim or Indian will be the bag. The head will be glued onto the top of the bag as shown.

4. Paint the body of the person, or use colored fabric or paper for the body, face, and hat or headdress.

5. Glue arms and any other details as desired.

6. Students wishing to be more elaborate may want to make a background for their person, or an entire group of individuals.

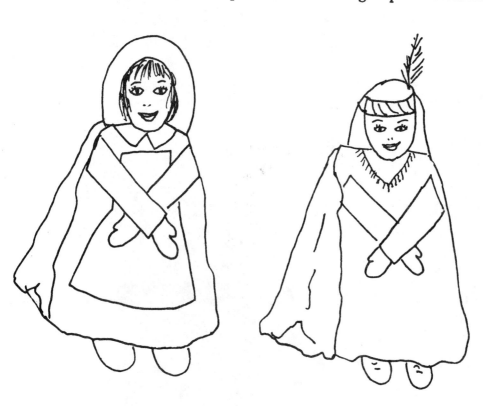

THANKSGIVING: PILGRIMS & INDIANS - 3RD GRADE

SUPPLIES: Cardboard toilet tissue or paper towel tubes, tempera paints & brushes, glue, scissors, fabric & paper scraps, yarn, and a pencil.

PROCEDURE:

1. Students will be making cardboard tube Indians & Pilgrims. Use a tube for the body, and another piece (that is the same width as the tube) for the head of the person.

2. Glue the head tube onto the body tube. Glue on paper yarn, or fabric hats, hair, and arms. Faces and clothing can be painted with tempera or acrylic paints.

3. Students can make boats or canoes to put the people in, if desired.

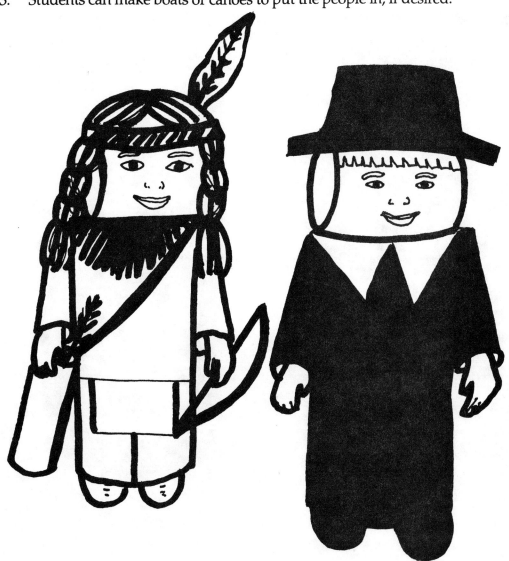

CHRISTMAS PROJECTS: KINDERGARTEN

CHRISTMAS SCRATCHBOARDS

SUPPLIES: Pencil, tagboard, red & green paint & crayons, soap, brushes, and a scratching tool.

PROCEDURE:

1. Students will make a scratchboard with a Christmas picture. They may color the background first with green or red colors, and use the other color for the paint (green crayon/red paint).

2. See crayon techniques for the entire procedure. See example below.

CHRISTMAS CARD SILHOUETTES

SUPPLIES: Pencil, scissors, glue, white and colored papers, aluminum foil, and glitter.

PROCEDURE:

1. Students will make a Christmas card on white or colored paper. Choose white, red, or green for the card.

2. Fold the card in half, and draw a Christmas type SILHOUETTE (outline of an object) on another piece of paper. It can be a silhouette of: a bell, star, shepherd & sheep, candle, angel, wisemen on camels, house & tree, Christmas tree, bird, or the Holy Family. Use white, gold, red, green paper, or aluminum foil. Draw the silhouette, cut it out, and glue it on the front of the card. Glitter may be used too. Write the Christmas message inside.

CHRISTMAS SCRATCHBOARDS CHRISTMAS CARD SILHOUETTES

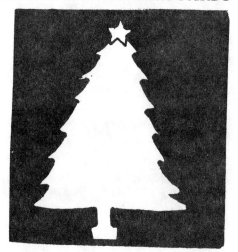
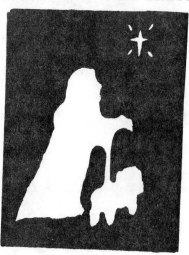

CHRISTMAS PROJECTS: KINDERGARTEN

CHRISTMAS TREE TOPPER

SUPPLIES: Pencil, scissors, glue, white & colored paper, glitter, stapler, and tagboard strips (2 x 9). Paints & brushes, markers, and crayons may be used for decorating too.

PROCEDURE:

1. Students will be making a tree topper. They can make stars, angels, trees, santas, reindeer, snowflakes, bells . . . If making stars, trees, angels, bells, or snowflakes, fold the white or colored paper in half. Then draw the picture, and cut it out.

2. Decorate the drawing with markers, paints, glitter, or any other materials you may have handy.

3. Trace the drawing on another paper, and decorate it also. Cut it out too.

4. Curl the tagboard into a circular shape, and staple it.

5. Glue or staple the 2 other papers on opposite sides of the tube.

6. Put the tree topper on the Christmas tree.

FOLD

PINE CONE ORNAMENTS

SUPPLIES: Pine cones, a glue gun (for adult use only), acorns, string, acorn caps, felt scraps, twigs, and jiggly eyes (optional).

PROCEDURE:

1. Using pine cones, acorn, acorn caps, felt, twigs, or any other materials, make an animal to hang on the Christmas tree. Glue together large parts with a glue gun.

2. Attach a string to hang up the ornament.

CHRISTMAS TREE TOPPERS PINE CONE ORNAMENTS

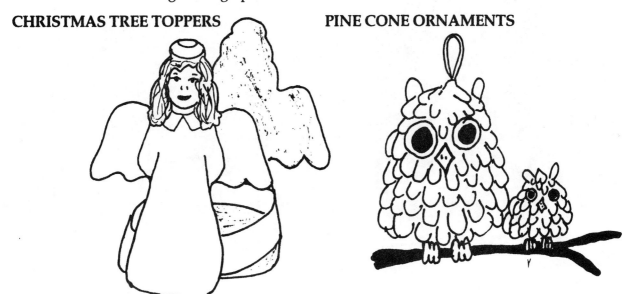

CHRISTMAS PROJECTS: 1ST GRADE

STAINED GLASS CRAYON RESISTS

SUPPLIES: Pencil, rulers, scissors, crayons, paints, brushes, paper, and tagboard.

PROCEDURE:

1. Fold a piece of 9 x 12 manilla paper in half as shown.

2. Draw and cut out a stained glass window shape for a pattern. Trace the pattern on a piece of tagboard. Cut out the tagboard window.

4. Draw pictures on the window, leaving spaces between each picture or design (to be painted).

5. Use brightly colored crayons to color the designs and pictures. Be sure to color very hard.

6. Paint black tempera paint over the entire window.

PRINTMAKING: GIFT WRAP

SUPPLIES: Pencil, assorted papers, such as colored and white tissue paper, tempera paint, a printing pad, and materials to print. Review printmaking unit.

PROCEDURE:

1. String a clothesline across the room.

2. Print white or colored tissue paper to be used as wrapping paper.

3. Hang up the tissue papers until dry. Have fun wrapping.

STAINED GLASS CRAYON RESISTS

PRINTMAKING: GIFT WRAP

CHRISTMAS PROJECTS: 1ST GRADE

WRAPPING PAPER ORNAMENTS & MAGNETS

SUPPLIES: Pencil, scissors, glue, assorted Christmas wrapping paper scraps, tagboard, a glue gun (for adult use), tape, wrapping ribbon, magnets (buy in a 3' strip), and rulers.

PROCEDURE:

1. Cut 2 pieces of tagboard the same size (3 x 4).

2. Cut 2 pieces of wrapping paper that is 1" larger on all sides.

3. Wrap 2 tagboard with the wrapping paper, and glue or tape well. Cut a small piece of white or wrapping paper that is a little smaller than the tagboard. Glue this piece over the taped & glued ends (see example). This will be the back part of the frame.

4. Cut a hole in the center of another tagboard for an opening for a photo.

5. Wrap with wrapping paper. Securely tape the ends.

6. Cut an X through the wrapping paper, and tape it to the back of the tagboard. See example.

7. Glue gun both pieces together on the bottom & sides.

8. Slip a photo into the frame, and attach a magnet or ribbon for hanging. Ribbon bows may be glued to the top of the frame (like a package).

CHRISTMAS CARDS

SUPPLIES: Pencil, scissors, glue, glitter, assorted papers, crayons, markers, or paints & brushes.

PROCEDURE:

1. Fold a 9 x 12 paper in half for a card. Draw a tree, snowman, reindeer, bell. . . on the front of the card, as large as possible. Make sure that some is still attached to the fold. Cut out the card white it's folded.

2. Decorate as desired.

WRAPPING PAPER FRAME ORNAMENT/MAGNET CHRISTMAS CARD

CHRISTMAS PROJECTS: 2ND GRADE

POPSICLE STICK PICTURE FRAME

SUPPLIES: Pencil, scissors, glue, tagboard, felt scraps or cork, and rulers. Each sudent needs 4 popsicle sticks too.

PROCEDURE:

1. Cut tagboard for the back of the frame (2-1/2 x 3-3/4 or 3-3/4 x 3-3/4). Cut sticks if desired.

2. Glue the top and bottom popsicle stick on the tagboard. Use regular glue or a glue gun.

3. Glue the other 2 popsicle sticks on the sides of the tagboard.

4. Customize the frame by adding cork or felt details. If making felt heads for the animals, cut a piece of tagboard to glue the felt to. Then glue the entire piece onto the frame.

5. Attach a stand (rectangular piece of tagboard, taped to the back) or a hanger (string, thread, or yarn-looped and taped to the back).

LACE ANGEL ORNAMENTS

SUPPLIES: 2 yards of lace per child (1-1/2" - 2" wide), scissors, 2 pipecleaners (gold or white) per child, and 1-3/4" white or beige bead per child. Permanent markers may be used to draw faces and hair on each bead. Thread for hanging.

PROCEDURE:

1. Accordion pleat 1' of lace (like a paper fan), and secure it with 1/2 of a pipecleaner in the center as shown.

2. Accordion pleat the second 1' piece of lace, and secure it with another 1/2 piece of a pipecleaner. Once piece of lace will be the angel and one piece will be the angel's wing.

3. If desired, use permanent marker to draw a face and hair on each bead.

4. Assemble the angel as shown. Use 1 entire pipecleaner and put the bead in the center. Make a halo with 1 end of the pipecleaner which is above the beaded face. With the other end of the pipecleaner, attach the head to the wings and body as shown. A small thread or ornament hanger may be attached to the angel's back.

POPSCILE STICK FRAMES **LACE ANGEL ORNAMENT**

CHRISTMAS PROJECTS: 2ND GRADE

PRINTMAKING: NOTECARDS

SUPPLIES: Pencil, assorted papers for notecards, tempera paint, a printing pad, and materials to print. Review printmaking unit.

PROCEDURE:

1. Cut all papers the exact sizes desired, and fold if necessary.

2. Print each notecard as directed. Prints can be Christmas symbols or pictures, or other objects, such as flowers, birds, butterflies

3. Let prints dry completely.

4. You can also make a nice paper folder for the cards.

WATERCOLOR CHRISTMAS CARDS

SUPPLIES: Pencil, glue, white and colored paper, water bowls, watercolor paints & brushes, table salt, and scissors.

PROCEDURE:

1. Fold 1 piece of colored 9 x 12 paper in half, for use as a Christmas card.

2. On a piece of 5-1/2 x 8-1/2 white paper, paint with watercolors this way: quickly dampen the paper with water, and quickly paint the entire paper blue. You can also add a little red or violet to the paper if desired. While the paint is still wet, quickly sprinkle salt over the entire paper. When dry, it will look like snow.

3. When dry, this painting can be glued, around the edges only, and placed on the front of the card.

4. Other details such as: Christmas trees, birds, snowmen . . . may be made on other papers, and glued onto the painting.

5. The message may be written on the inside of the card.

PRINTMAKING: NOTE CARDS

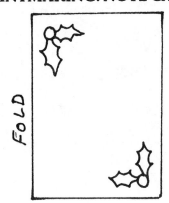

WATERCOLOR CHRISTMAS CARDS

CHRISTMAS PROJECTS: 3RD GRADE

CHRISTMAS CAROL MURALS

SUPPLIES: Mural paper, crayons, colored pencils, markers, or paints & brushes, pencils, and Christmas carols.

PROCEDURE:
1. Decide which Christmas carols will be used for the murals. Have groups of 4-5 students per mural.

2. Decide which words can be drawn instead of written. For example: Horse, sleigh, snow, bells, . . . Parts of words can also be written and drawn. For example: the word-making, could be done: MA-(picture of a king).

3. Have students draw their ideas on scrap paper first.

4. Draw and color as desired on the mural papers. This can also be done on individual cards, but they should be on large papers.

GRAHAM CRACKER HOUSES

SUPPLIES: Graham crackers, prepared or homemade icing recipe (3 egg whites, 1 tsp. cream of tartar - beat well. Add 1 lb. powdered sugar & mix. Keep covered when not using.) Cardboards or plates to place the houses on, and any assorted materials for decorating: lifesavers, raisins, gumdrops, cookies, sprinkles, cereal, nuts, licorice, candy bars....Use plastic knives for applying icing.

PROCEDURE:

1. Give students icing and graham crckers to assemble their houses on a sturdy surface. Graham crackers can be carefully broken.

2. Decorate as desired.

CHRISTMAS CAROL MURAL GRAHAM CRACKER HOUSE

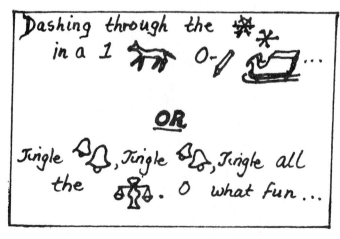

CHRISTMAS PROJECTS: 3RD GRADE

CHRISTMAS TREE GARLAND

SUPPLIES: Pencil, scissors, glue, markers, yarn, glitter, and assorted papers.

PROCEDURE:

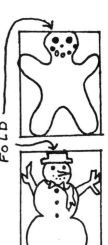

1. Give each child a 6' piece of yarn for the garland.

2. Use 3 x 9 strips of white and colored papers to decorate the garland. Fold paper in half, and draw: snowmen, gingerbread men, Christmas trees, angles, bells . . . Make sure that part of the drawing is attached to the top fold.

3. Cut out the shapes (white folded).

4. Decorate 1 side of each shape as desired.

5. Glue each shape onto the yarn, with the yarn between both halves of each shape.

6. Leave spaces between each shape that is glued on the yarn. Hang on the tree when finished.

3D CHRISTMAS CARDS

SUPPLIES: Pencil, scissors, glue, assorted papers, glitter, and crayons or markers.

PROCEDURE:

1. Fold a 9 x 12 piece of white or colored paper in half, for a card.

2. Glue a design or picture to the front of the card. Use other pieces of paper, and fold, curl, bend, or twist them, so the picture is 3D. Review the paper sculpture unit.

3. Finish as desired. Include message on the inside.

CHRISTMAS TREE GARLAND

3D CHRISTMAS CARDS

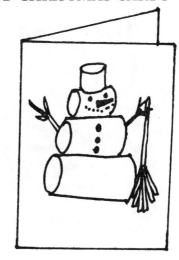

PRESIDENTS' DAY: KINDERGARTEN

PRESIDENT SILHOUETTE WITH STYLE

SUPPLIES: Pencil, scissors, glue, rulers, white, red, and blue paper, and stars, sequins, and something to color the profile insides: crayons, markers, or paints and brushes.

PROCEDURE:

1. Review PROFILE UNIT AND DESIGN UNIT with class.

2. Students may draw 1 of the President's heads on white paper. A profile drawing works the best. If necessary, the teacher can run off pre-drawn profiles for each student.

3. Have students decorate the inside of the profile with stars, stripes, flags, drawings, or whatever they think is appropriate. Use crayons, markers, or paints. Sequins, stars, or other objects may also be glued on the profile. Try to have each student use their own designs, so each profile is unique.

4. Cut out the profile, and glue it on a larger red or blue paper.

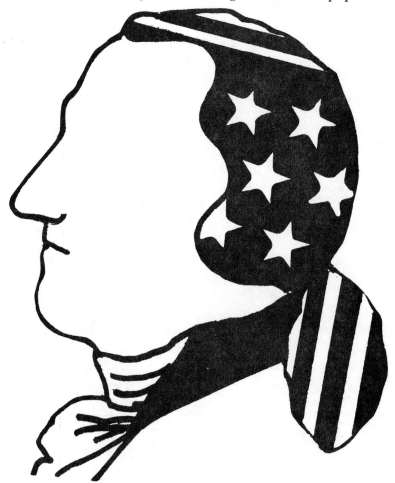

PRESIDENTS' DAY: 1ST GRADE

MAKING REAL FLAGS

SUPPLIES: Pencil, ruler, crayons, markers, or paints and brushes, and white paper. Colored paper, scissors, and glue may be used also. For an edible variation, graham crackers and assorted color icing may also be used.

PROCEDURE:

1. Review FLAGS in the encyclopedias. Show students the various flags for the United States and for other countries.

2. Students can draw a copy of a real flag for any country, and color or paint it. They may also use colored construction paper for stripes or other designs on the flag. Graham crackers and colored icing can be used for "edible flags."

MAKING IMAGINARY FLAGS

PROCEDURE:

1. Students can draw imaginary flags for a real or imaginary country. Decorate and color as desired.

REAL FLAG **IMAGINARY FLAG**

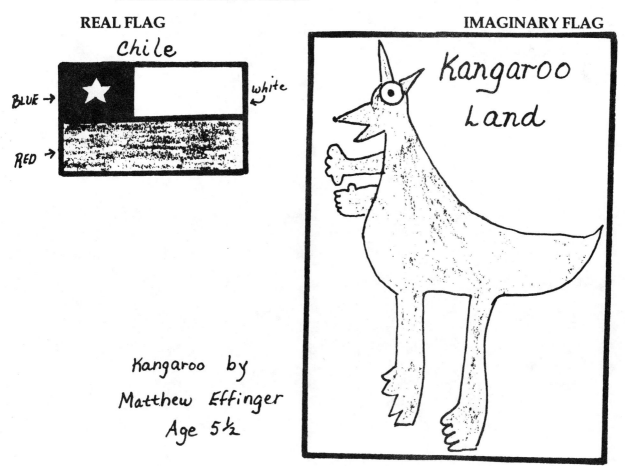

Chile

BLUE →
RED →
white ←

Kangaroo Land

Kangaroo by
Matthew Effinger
Age 5½

PRESIDENTS' DAY: 2ND GRADE

PRESIDENT'S HOME - PAST OR PRESENT

SUPPLIES: Pencil, scissors, glue, colored and white paper, clean milk cartons, colored tissue paper, sticks, and sturdy cardboard (corrugated cardboard or shoe box lids work great), crayons, markers, or paints and brushes may be used also.

PROCEDURE:

1. Review Presential homes of the past, such as Lincoln's log cabin, and the home of today, the White House.

2. Give each child 1 or more clean milk cartons. This will be used for the shape of the house. Windows and doors can be cut out with scissors.

3. Use colored construction paper, white paper, or corrugated cardboard (so the bumps show) to decorate the house walls and roof. If needed, an adult may use a hot glue gun to glue objects onto the milk carton. If students want to paint the outside of the milk cartons, use a little soap mixed with tempera or acrylic paint.

4. The houses may be glued onto a stiff cardboard, and the cardboard may be colored or painted also. Sticks or tissue papers may be used for bushes and trees. Add any details desired to make each one unique.

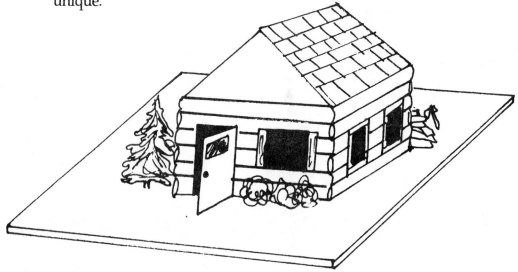

PRESIDENTS' DAY: 3RD GRADE

SHADOWBOX OF PRESIDENT'S HOME - PAST OR PRESENT

SUPPLIES: Pencil, scissors, glue, white and colored paper, corrugated cardboard, shoe boxes, small spools or boxes, tissue paper. . . Crayons, colored pencils, markers, or paints and brushes may be used to color the shadowbox, figures, or furniture. Twigs or popsicle sticks, and fabric scraps are also useful. Wallpaper scraps may be used also.

PROCEDURE:

1. Review Presidential homes of the past, such as Lincoln's log cabin and the home of today, the White House.

2. Give each child a shoebox for the basic structure of the shadowbox. Turn the box on its side, and cut out any doors or windows that are needed. Fabric may be glued on the windows for curtains.

3. Decorate the walls with white or colored paper, wallpaper, crayons, markers, or paints. Remember, this is the inside of the room. Small pictures may be drawn and glued on inside walls.

4. Decorate the outside walls with paints, paper, corrugated cardboard, popsicle sticks . . .

5. On other paper, draw and color furniture, animals, or people. Cut out and glue inside the shadowbox. Be sure to make tabs on the bottom. (See example.)

6. Add any other desired details: mirrors, plants, small spools or boxes for furniture . . .Paper may be rolled, curled, or folded for furniture.

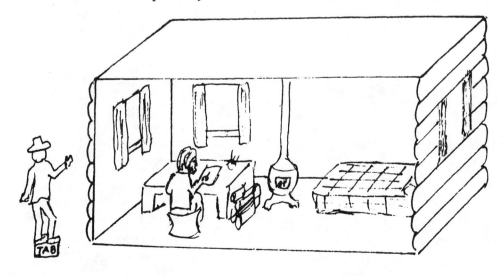

VALENTINE'S DAY: KINDERGARTEN

LOVABLE TREATS

SUPPLIES: Pencil, scissors, glue, paints and brushes, crayons, markers, and large white paper.

PROCEDURE:

1. Give each child a large white paper (at least 12 x 18).

2. Have students draw their favorite "fantasy food". This can be a hot fudge sundae, pizza, or whatever . . .

3. Decorate the fantasy food with loving messages, hearts, flowers, cupids, stripes, stars, or as desired. Use any listed materials, or others that you may have on hand. Have each "treat" be unique. You may want to add minature people skiing down the mountain of whipped cream. Use your imagination.

4. Cut out the "lovable treats". These can be used for valentines, wall hangings, or valentine card holders. For a valentine card holder, simply attach a card pouch. To make the pouch: Fold a piece of 12 x 18 white or colored paper in half. Decorate if desired. Staple, tape, or glue the pouch to the bottom of the treat.

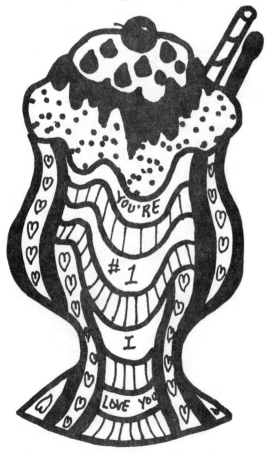

CURVE THE BOTTOM

VALENTINE'S DAY: 1ST GRADE

CUPID CARD HOLDER

SUPPLIES: Pencil, scissors, glue, white and colored paper, tape, a stapler, and crayons, colored pencils, or markers.

PROCEDURE:

1. Draw and decorate a cupid on 12 x 18 white or colored paper.

2. Loving messages, designs, hearts, flowers, stars, stripes....may be put on the front of the cupid too.

3. Fold a piece of 9 x 12 paper in half, for use as a card holder.

4. Fold the paper in half again, the other way, and cut out a heart as shown. (You will have 2 hearts when finished.)

5. Glue or staple the 2 hearts together, but leave an opening in the top for the cards entrance. Decorate.

6. Glue, staple, or tape the card holder to the cupid.

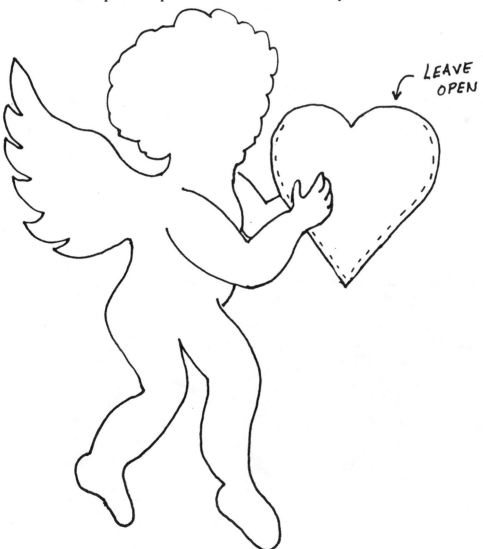

LEAVE OPEN

VALENTINE'S DAY: 2ND GRADE

LACED HEART CARD HOLDER

SUPPPLIES: Pencil, scissors, yarn, hold punch, glue, crayons, colored pencils, or markers, tape, and assorted white and colored papers.

PROCEDURE:

1. Give each child 2 - 12 x 18 peices of white or colored paper. (This will be used for a heart.)

2. Put the 2 papers together, and fold in half as shown. Draw 1/2 of a heart, and cut it out. When finished, you will have 2 hearts.

3. Fold down the top 1/3 of 1 heart, and cut it off. This will be the card pouch.

4. Put both hearts together, and punch holes all the way around them. This will be used for yarn lacing, to put the 2 pieces together.

5. Attach a small piece of tape to a piece of yarn that is about 3' long.

6. Lace the hearts together and decorate as desired. You can glue on an arrow, cupid, heart creatures, color designs

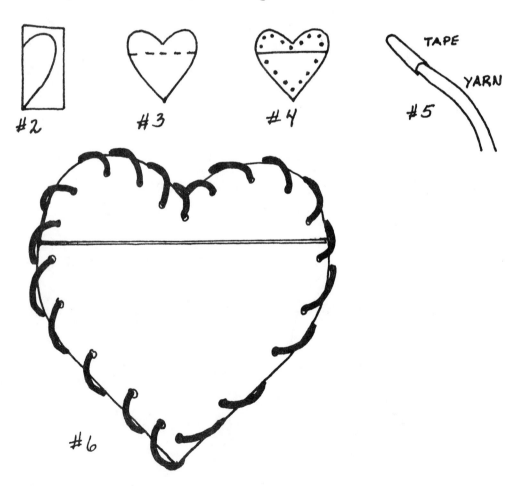

#2 #3 #4 TAPE YARN #5

#6

VALENTINE'S DAY: 3RD GRADE

VALENTINE WITH POP OUT HEART

SUPPLIES: Pencil, scissors, glue, assorted white and colored papers, crayons, colored pencils, or markers, and rulers.

PROCEDURE:

1. Give each child a piece of 9 x 6 white or colored paper. This will be used for the outside of the card.

2. Fold the paper in half, fold on the left side, and decorate the front of the card as desired.

3. Cut a piece of paper for the pop out heart. It should be a 5" square. Fold it in half, and cut out a heart, as shown.

4. Make a 6" long arrow out of another piece of paper. Cut the arrow in half as shown, and glue it on the heart.

5. Glue the other end of the arrow to the back side of the heart.

6. Decorate the heart as desired. Words, designs, cupids, or anything else may be drawn, colored, or glued onto the heart.

7. To attach the heart to the card: Have the front of the heart lying on the table, facing you. Make a fold on each side of the heart as shown. Fold the side pieces up, toward you.

8. Place the heart inside the card, and experiment with different positions. When you've decided where the heart looks the best, put glue on the flat, folded part only. Glue into position, close the card, and let it dry.

9. Glue the 2 ends of the arrow to the card and finish the inside message.

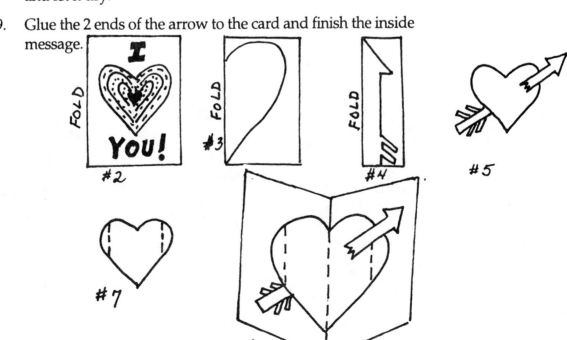

EASTER: EGGSHELL SPROUTS - KINDERGARTEN

SUPPLIES: Empty blown eggshells, empty toilet tissue rolls (1/2 per child), cotton balls, alfalfa seeds, water, and markers or paints and brushes. Colored paper, scissors, glue, yarn, and fabric scraps may be desired.

PROCEDURE:

1. Blow out eggshells, and rise thoroughly. To blow out eggshells: use a straight pin to poke a small hole in the top of the egg, and a larger directly below it. (See example.) Place a container under the egg, and gently blow the contents into the container. When empty, rise, and dry.

2. Cut toilet tissue rolls in half as shown.

3. Break off part of the top of the egg about the same size as a quarter. This will be the opening for the sprouts that grown.

4. Glue the bottom of the egg onto the tissue roll.

5. Decorate the tissue roll and egg. Remember: the alfalfa sprouts will grow out of the top of the egg. Use any of the listed materials, or other you may have.

6. Place 3-4 damp cotton balls in the bottom of each egg, and sprinkle 1/4 - 1/2 tsp. of alfalfa seeds on top of the cotton. Within a few days, the seeds will sprout.

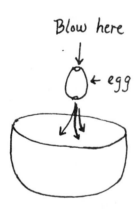

Blow here

← egg

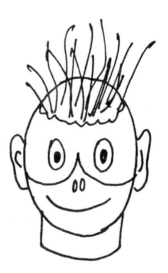

EASTER: STYROFOAM EGG TREE - 1ST GRADE

SUPPLIES: Styrofoam eggs (any size - 1 per child), scissors, egg tree, fabric scraps, glue, yarn or string, and other notions to decorate the egg (ribbon, lace, pearls, sequins. . .). Tacky glue or a glue gun may be useful too.

PROCEDURE:

1. Make an egg tree from a large tree branch, and place it in a bucket of plaster. When the plaster is hard, the tree is ready for use.

2. Give each child a styrofoam egg and fabric scraps. Students can cut the scraps into any shape (use 1 or more types of fabric for each egg), and use a sharp object (the end of a pair of scissors) to push the ends of the fabric into the styrofoam. Put 1 piece of fabric on the egg at a time. If 1 piece doesn't exactly fit the space, it can be trimmed.

3. When the entire egg is covered with fabric, other materials: sequins, pearls, ribbons . . . may be glued on to cover the cracks between pieces of fabric.

4. When finished decorating the egg, a ribbon or string can be glued or pinned to the top of the egg for hanging on the tree. See example.

EASTER: FLOWER IN PLANTER - 2ND GRADE

SUPPLIES: Paper cups (1 per child), pipe cleaners, colored paper, modeling clay (the size of a small ping pong ball for each child), tissue or crepe paper, and crayons, markers, or paints & brushes to decorate the planters.

PROCEDURE:

1. Give each child a paper cup and a piece of modeling clay. Put the clay inside the cup.

2. Have students decorate the cup as desired for an Easter planter. (Decorate the outside only.)

3. Make tissue paper or crepe paper flowers to put in the planter.

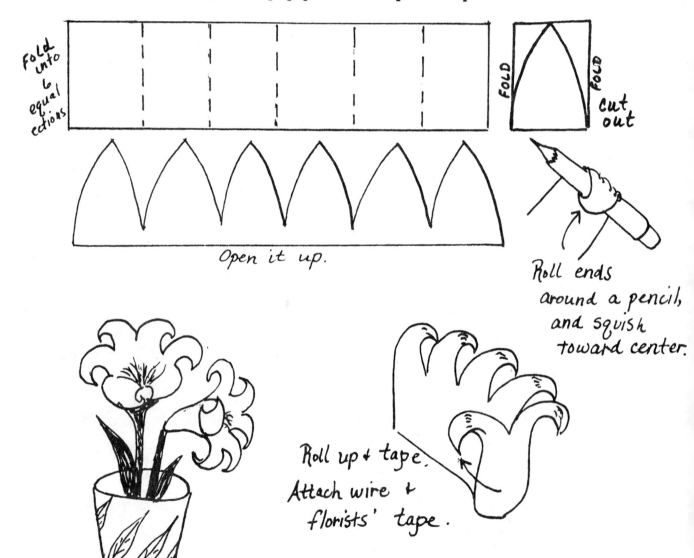

EASTER: WOVEN BASKET WITH ANIMAL - 3RD GRADE

SUPPLIES: Pom poms and felt scraps for animals, Easter grass, scissors, glue (tacky glue works great), yarn scraps, scotch or masking tape, and strawberry crates.

TO MAKE BASKETS

PROCEDURE:

1. Give each child a peice of tape (1" long), a strawberry crate, and yarn scraps. The tape should be wrapped tightly around 1 end of the yarn. This will be used like a needle.

2. Have students weave the crate, row by row, starting at the bottom of the crate. Make sure that all loose ends of the yarn are tied in a knot to the crate.

3. If desired, scrap felt or other materials may be glued onto the woven basket. A handle may be added if necessary. Use a piece of tagboard, colored paper, or wire.

4. Put Easter grass in finished baskets.

TO MAKE ANIMALS

PROCEDURE:

1. Students can make any type of animals that they want using pom poms and felt. Glue with tacky glue if possible. Yarn scraps, pipe cleaners, jiggly eyes, or other materials may be used also.

2. When animals are dry, place into the finished baskets for a great Easter Centerpiece. Jellybeans, eggs, or other objects may be added also.

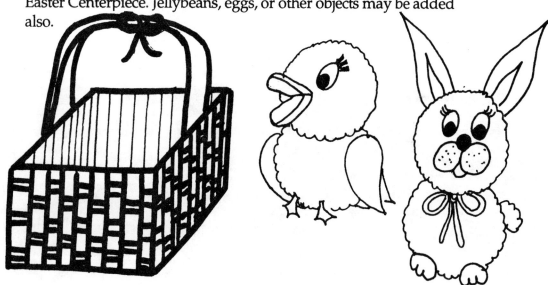

MOTHERS' DAY: KINDERGARTEN

BOUTIQUE SOAPS

SUPPLIES: Soap, paraffin wax, tongs, coffee can, glue, scissors, heat source to melt the wax, and a decal-cut from a wrapping paper, a paper napkin, or old greeting card.

PROCEDURE:

1. Give each child a bar of soap. With a scissors, have students smooth out the brand name on the soap.

2. Have students wet a finger, and smooth out the front of the soap.

3. To decorate the soap: make a decal cut from a piece of paper napkin, wrapping paper, or greeting card. Glue the decal on the front of the soap.

4. Melt paraffin wax in the bottom of a coffee can.

5. Hold the soap with tongs, and dip it in the wax mixture half of the way. Dip twice for longer use of the soap. THIS STEP SHOULD ONLY BE DONE BY THE TEACHER OR ANOTHER ADULT.

6. The soap may be decorated more by using small plastic or silk flowers or leaves. Simply cut to the desired size, and push into the top side of the soap.

MOTHERS' DAY CARDS

SUPPLIES: Pencil, scissors, glue, white and colored paper, crayons, yarn, markers, or prints & brushes, and aluminum foil.

PROCEDURE:

1. Fold white or colored paper (9 x 12) in half for a card.

2. Cut an oval or heart shape on the front side of the card.

3. Behind this opening, on the inside, glue a piece of aluminum foil to the card. This will look like a mirror.

4. Decorate the front and inside of the card for mothers, grandmothers, or someone special. Yarn may be glued on around the opening on the cover and also tied into a bow.

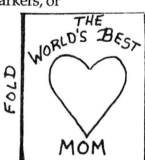

THE WORLD'S BEST
FOLD
MOM

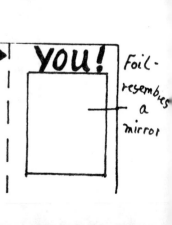

is ➡ you!

I LOVE YOU!

Foil-resembles a mirror

MOTHERS' DAY": 1ST GRADE

MEMO BOARDS

SUPPLIES: Pencil, scissors, glue gun for an adult to use, glue, paper, and 1 of the following for the memo board base: stiff cardboard covered with contact paper, a stiff piece of cork board, or carpeting scraps. Markers or paints may be used to decorate the memo board or the papers inside of it.

PROCEDURE:

1. The base of each memo board should be cut out by the teacher. It can be an oval, rectangle, heart, or animal shape. A utility knife may work better than scissors.

2. A pocket should be made to glue gun onto the base. This should be done by an adult. Glue on 3 sides only, leaving the top open.

3. Students may then decorate the memo boards as desired.

4. Paper can be cut to fit in the pocket of the memo boards. Students can decorate the papers with any of the above listed materials or others of their choice. Students may also use printmaking techniques to decorate the papers.

5. A piece of yarn and pencil may be attached if desired.

MOTHERS' DAY: 2ND GRADE

SCRIMSHAW JEWELRY OR MAGNETS

SUPPLIES: Pencil, scrap paper, wax paper, water, stirring sticks, bucket, nails or compasses, spray varnish, markers, brushes, watercolor paints, and a few magnet rolls or jewelry findings. Students can use this technique to make magnets, pins, necklaces, or earrings.

PROCEDURE:

1. Mix a batch of plaster of paris in a bucket as directed. A pound bag should be plenty for a class. As soon as the mixture is smooth, pour it on a large piece of wax paper in small circles or ovals. Don't let the circles touch each other. Don't make the circles too large either. Experiment with other shapes that can be made with the plaster on the wax paper.

2. Let plaster dry, and remove from the wax paper. Give each child 1, 2, or more pieces of plaster.

3. If making magnets: trace the shape of the plaster on a piece of scrap paper, and make drawings to decorate the magnet. Try several different drawings, and select the best one. Words may be added: I love you, mom . . .

 If making jewelry: trace the shape(s) of the plaster on a piece of scrap paper, and make drawings or designs to decorate the jewelry. Try several drawings and select the best one. Words may be added: I love you, mom . . . THEN DRAW THE DESIGNS ON THE PLASTER.

4. Scrape the lines with a sharp object: compass tip or nail.

5. Paint black watercolor paint over the lines. Rub off the extra paint, so only the cracks are filled with paint, with a kleenex. Use markers or watercolors to paint the plaster as desired.

6. When dry, spray with varnish. Attach magnets or jewelry findings.

Draw design. **Paint it.** **Rub off the excess.** **Paint.**

 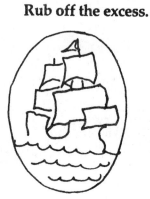 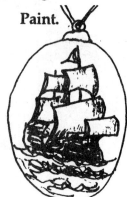

MOTHERS' DAY: 3RD GRADE

INLAID WOODGRAIN PICTURES

SUPPLIES: Pencil, assorted woodgrain contact paper, paper, scissors, and tagboard or cardboard, 4 x 5 or 5 x 7.

PROCEDURE:

1. Students will be making an inlaid woodgrain picture. This is normally done with various types and colors of wood which are cut, like a jigsaw puzzle, and glued together on another piece of wood.

2. On scrap paper, draw a picture of a scene, still life, or animal. The scrap paper should be the exact same size as the tagboard or cardboard.

3. Cut the pieces apart to use for contact paper patterns.

4. Use the patterns to trace shapes on various types of contact paper.

5. Cut out the different shades of woodgrain contact paper for each part of the picture. A large rectangle may be drawn and cut out for the sky or background.

6. Starting with sky or background, stick the contact paper onto the tagboard. Then gradually stick other pieces of contact paper on the tagboard, layer by layer. PUT THE FOREGROUND ON LAST.

REMEMBER TO MAKE THE PICTURE AS INTERESTING AS POSSIBLE, AND TRY TO PLACE LIGHT PIECES NEXT TO DARK PIECES FOR GREATER CONTRAST.

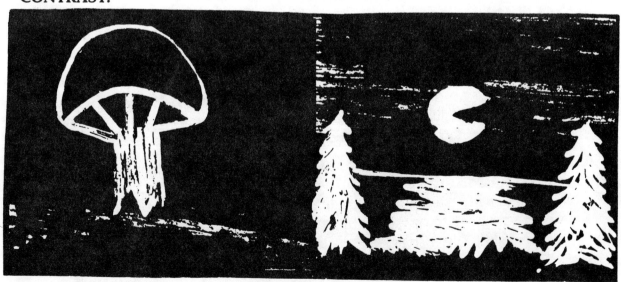

RECIPES

PLAY CLAY: Mix together: 1 c. flour, 1 c. water, 1/2 c. salt, 1 TBSP. oil, 1 tsp. cream of tartar, and food coloring. Cook mixture over low heart until it pulls away from the sides of the pan, like play dough. Knead, and keep in plastic container when not in use. It keeps several months.

DOUGH JEWELRY, MAGNETS, & ORNAMENTS: Dissolve 1/4 c. salt in 3/4 c. warm water. Add food coloring & mix. For a marbled effect, add the food coloring after the flour is added. Add 1-3/4 to 2 c. flour to the mixture. Use a few drops of water when attaching pieces together, so the dough will stick together. (Make: rainbows fruits, flowers, animals . . .) Stick paper clips in back of soft clay to use as hangers. Bake at 300 degrees for 1 hour. These can also be painted with acrylics or tempera paints. Spray varnish if using tempera paints.

WINDOW PAINTS: Mix dry tempera paint with a little liquid soap & water until smooth. Paint on the windows with brushes. Simply scrape with a razor blade to remove the paint. Wash residue with water.

RELIEF MAPS OR ORNAMENTS: Mix together: equal amounts of flour & salt with a few drops of water. Add dry or wet tempera paint or food coloring for desired color.

PRINTING PAD: Cut 20 thicknesses of newspaper (5" x &") or larger. Saturate with water, and sprinkle dry or wet tempera paint onto the surface. Blend with a brush if needed.

PAPER MACHE': 4 RECIPES: Mix: flour & water, white school paste & water, wheat paste & water, or wallpaper paste & water - until it is smooth and creamy, like pudding. Use this method for dipping newspaper strips.

TO MIX PLASTER OF PARIS: 1. Pour water into container. 2. Put plaster into water, and break up clumps. 3. Let set 2-3 minutes. 4. Slowly stir with a spoon or hand. 5. If pouring into a mold, tap mold gently (after the mixture is in the mold), to remove air bubbles. Let dry. It will expand slightly.

FINGERPAINTS: Mix together: 2 c. flour & 2 TBSP. salt. Gradually add 3 c. cold water, and stir. (Use a mixer if desired.) Add 2 c. hot water to mixture, and heat until boiling and smooth. Color with food coloring or liquid tempera paint.

RELIEF MAPS: Use paper mache', dough, or plaster of paris. Build the armature on wood or cardboard. Crunched up newspapers, cardboard, paper bags, paper rolls, aluminum foil, chicken wire, or balloons may be used to build the armature. Paint with acrylic or tempera paints. Spray varnish if using tempera paints. Tissue paper, fabric, sticks, stones . . . may be glued onto the painted surface.

Rainbow Artists Press
7014 248th Avenue
Box 254
262-843-3430 Phone/Fax
rainbowartist@msn.com

SHIP TO: (return shipping guaranteed)

ORDER DATE
SHIP DATE
Shipping Method

PO #
Customer #

INVOICE

Please make check to: Rainbow Artists Press

Qty	ISBN	Description	Unit Price	Total Price
		ART CURRICULUM BOOKS		
	0-9633334-6-1	Teaching Art the Easy Way: K-3 (over 200 lessons)	$26.95R	
	0-9633334-7-x	Teaching Art the Easy Way: 4-8 (over 150 lessons)	$26.95 R	
			Subtotal	
		SHIPPING $2.00 each- book rate		
		NEW CHILDREN'S BOOKS		
	0-9633334-1-0	Alice The Pony	$5.00	
	0-9633334-2-9	Mean Mike the School Bully	$5.00	
	0-9633334-0-2	Stinky My Best Friend: Stinky the Skunk	$5.00	
		SHIPPING $1.00 each	SHIP	
			Shipping	
			SubTotal	
		WI Residents Only: 5.5% or Your TAX Exempt #	TAX	
			TOTAL	

Payment is due within 30 days.

Thank you for your order.

Rainbow Artists Press
7014 248th Avenue
Box 254
262-843-3430 Phone/Fax
rainbowartist@msn.com

SHIP TO: (return shipping guaranteed)

ORDER DATE
SHIP DATE
Shipping Method

PO #
Customer #

INVOICE

Please make check to: Rainbow Artists Press

Qty	ISBN	Description	Unit Price	Total Price
		ART CURRICULUM BOOKS		
	0-9633334-6-1	Teaching Art the Easy Way: K-3 (over 200 lessons)	$26.95R	
	0-9633334-7-x	Teaching Art the Easy Way: 4-8 (over 150 lessons)	$26.95 R	
			Subtotal	
		SHIPPING $2.00 each- book rate		
		NEW CHILDREN'S BOOKS		
	0-9633334-1-0	Alice The Pony	$5.00	
	0-9633334-2-9	Mean Mike the School Bully	$5.00	
	0-9633334-0-2	Stinky My Best Friend: Stinky the Skunk	$5.00	
		SHIPPING $1.00 each	SHIP	
			Shipping	
			SubTotal	
		WI Residents Only: 5.5% or Your TAX Exempt #	TAX	
			TOTAL	

Payment is due within 30 days.

Thank you for your order.